Carbon County

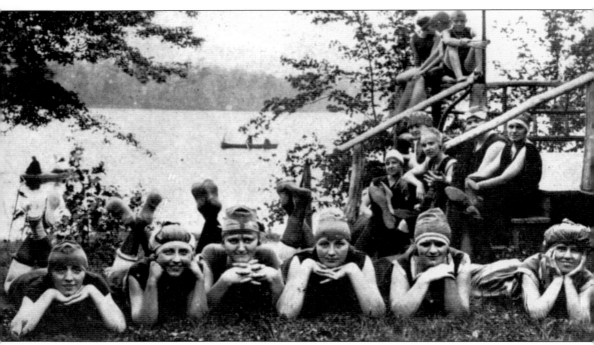

SUNBATHERS. Bathing beauties enjoy a 1915 outing at beautiful Lake Harmony, one of the most popular recreational areas in Carbon County. (Postcard courtesy of Glenn Finsel.)

POSTCARD HISTORY SERIES

Carbon County

Rebecca Rabenold-Finsel

ARCADIA

First published 2004

Published by Arcadia Publishing,
Charleston SC, Chicago IL, Portsmouth NH, San Francisco CA

Printed in Great Britain

Library of Congress Catalog Card Number: 2004103898

For all general information, contact Arcadia Publishing:
Telephone 843-853-2070
Fax 843-853-0044
E-mail sales@arcadiapublishing.com
For customer service and orders:
Toll-free 1-888-313-2665

Visit us on the Internet at www.arcadiapublishing.com

On the cover: Carbon County residents enjoy a Fourth of July picnic *c.* 1917 in Lowrytown (Laurytown), a rural area in Carbon County near Weatherly and Rockport, and home to the Middle Coal Field Poorhouse. (Postcard courtesy of Richard Funk.)

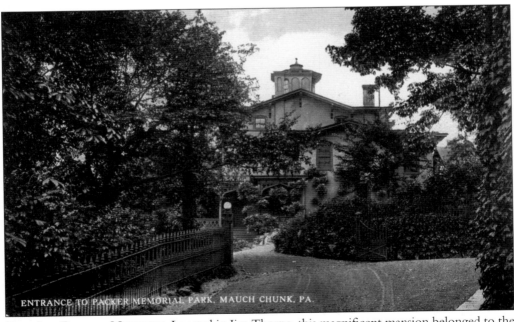

THE ASA PACKER MANSION. Located in Jim Thorpe, this magnificent mansion belonged to the Honorable Asa Packer, founder of the Lehigh Valley Railroad and Lehigh University. (Postcard courtesy of Fred Bartelt.)

CONTENTS

ACKNOWLEDGMENTS

For their tremendous generosity, I would like to thank historian and collector Clarence Getz; historian Lee Mantz; and collectors Juliana Rhodes, Hilbert Haas, Richard Funk, Fred Bartelt, Nancy Shaffer, Cynthia Finsel-Sweitzer, Barbara Gelatko, Robert Gelatko, and Leah Wehr. Their wonderful postcards are, indeed, the focal point of this book. Also, thanks go to my husband, Glenn, for his unfailing encouragement and for the use of his postcard collection and his vast library of Pennsylvania history. Thanks go to my parents, Randolph and Ruth Rabenold, for instilling in me the magic of creativity and an insatiable love of books. In addition, I thank my sons, Joshua, Joel, and Daniel, a constant source of inspiration.

INTRODUCTION

I can hardly write, we are going so fast!

—Switchback postcard, Mauch Chunk, 1907

In the Victorian era, postcards defined popular culture in the same way e-mail and the Internet define our lives today. Whether conveying news of a safe arrival, time of departure, or words of joy or tragedy, postcards are more than mere pieces of paper. They are treasured remnants of history and a currency unto themselves. A postcard from Rockport, dated 1918, demonstrates the valuable commentary that some postcards possess: "Dear Ruth, Arrived here last night on the 9 o'clock train, there was a wreck and I missed my connection at Allentown. Bernard Heiney drowned in the Lehigh River Tuesday evening and his body was found Wednesday. I was down along the Lehigh all day yesterday. Allen."

During the 19th century, traveling, or "excursioning," became extremely popular and was no longer confined to the wealthier classes. Trips to the mountains, seaside resorts, and places of amusement were deemed therapeutic. Along with increased travel, the public became addicted to postcards, with over six million cards mailed in 1908 alone. Whether kept as treasured souvenirs or sent to friends and family back home, postcards became synonymous with travel. They were picturesque, gave a sense of locale, and had just enough space for a bit of news without demanding a long dissertation.

Blessed with a unique geography, Carbon County dazzled the adventurous travelers of the Victorian era, just as it attracts adventurers today. Aesthetically not much has changed of this unique landscape written about in the 1877 book *Highways and Byways of American Travel*: "Such . . . rough and tumble experience, climbing mountains, falling over rocks, exploring wild ravines, diving into coal mines, and riding on every description of conveyance which it has entered into the mind of man to run on."

For the more cerebral traveler, Carbon County has a rich history. Some interesting people have passed through these mountains, including Count Zinzendorf, Moravian mystic; John James Audubon in his "satin breeches and dancing pumps"; and Benjamin Franklin. Although these men were born too early to appear in postcards, their stories are woven through the text with

those of Josiah White, Erskine Hazard, Asa Packer, and Jacob Weiss, whose achievements in Carbon County changed American history, leaving legacies that still inspire us today.

In this book you will see pictures of people who have walked before us and of places altered by time, all preserved by postcard photographers such as Martin D. Martz, Bert Luckenbach, J. F. Miller, C. H. Bretney, J. Mankos Jr., and others, unsung heroes of magic places.

Although not all of the parts of Carbon County are visually represented here, this does not make their history less meaningful; for if not here in pictures, they are here in spirit.

One

ST. ANTHONY'S WILDERNESS

*While the Indian hated the white, who had stolen
'the ground on which he slept,' he was kind to the Brethren.*

—*The Moravians and Their Leader*

The first settlement in Carbon County was the Moravian mission Gnadenhutten, established in 1745. Deeply moved by the "deplorable state of the savages in America," 12 Moravian missionaries left their home in Herrnhut, Germany, and traveled by sea to the wilderness of Pennsylvania, a place known for religious tolerance.

Located where Lehighton now stands, Gnadenhutten exemplified communal simplicity. Home to hundreds of Lenni Lenape (Delaware) and Mahican Indians after their religious conversions, the mission was a "scene of quiet, humble and unobtrusive heroism" and the Indians' shelter from adverse "influences of their own race."

By 1752, increased American Indian hostility put Gnadenhutten at risk for attack, but the missionaries' pious good works did not go unnoticed. "The frankness and earnestness of the simple Moravians" had won respect with the American Indians, and they lived without incident until 1755. Not limited to their work at Gnadenhutten, the Moravians worked diligently in the field, ministering to famine-struck American Indians in the Wyoming Valley. Although the wilderness was quite treacherous, the Moravians traveled in the wilds of Carbon County undaunted. Moravian John Martin Mack describes his Lehigh River journey in 1746 as follows:

> In the morning early it began to rain. . . . Fearing the Lehigh . . . we tried to wade it. It was so extremely cold that at first we thought it impossible for us to endure. When we got about the middle, it was so deep that I thought every minute it would bear me down. [I took] Brother Christian by the coat and helped him through. We had gone about 12 miles and made a fire, but could not make it burn because it snowed so hard. The cold pierced us. . . . We were through and through wet. We cut wood all night to prevent being frozen to death.

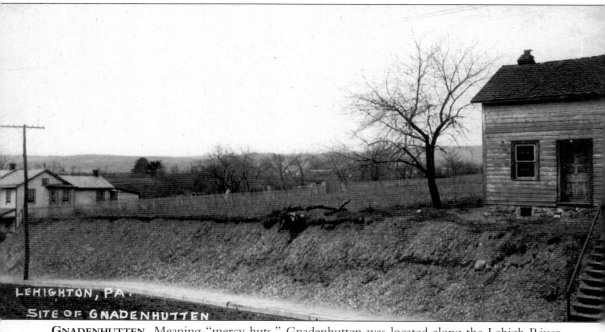

LEHIGHTON, PA.
SITE OF GNADENHUTTEN

GNADENHUTTEN. Meaning "mercy huts," Gnadenhutten was located along the Lehigh River "on the north side of Mahoning Creek." The land, discovered by Moravian leader Count Zinzendorf, appealed to him while he was traveling by canoe on the Lehigh River. Strategically chosen for location, Gnadenhutten lay between the Moravians in Bethlehem and their American Indian interests to the north. Arriving at Gnadenhutten with nothing but a fervent desire to "instruct the heathen," the Moravians "sacrificed all luxury working ceaselessly, assuming every burden . . . and adopting the Indian costume." Over 500 souls lived at Gnadenhutten, and each American Indian family had land to farm. "The church stood in a valley . . . upon rising ground were the Indian houses . . . and on the other [side] the mission house and the burying ground . . . the road to other Indian towns (Warrior's Path) lay through the settlement." (Postcard courtesy of Glenn Finsel.)

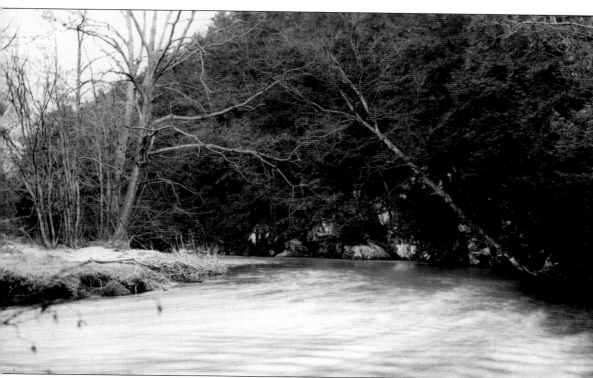

MAHONING CREEK. Gnadenhutten became an agricultural epicenter, and its log structures dotting the "unbroken forest" emphasized "the loneliness of the situation." Devoted to the American Indians, the missionaries were "ever by their side in all their wanderings, cheerfully bearing with them the heat and burden of the day." After a while, a neighboring plantation of "80 acres cultivated land, 20 acres meadow and 1,283 acres of bush [woods]" was purchased and a sawmill erected for "cutting timber and conveying it to Bethlehem . . . down the Lehigh." Hunting brought in "15–20 deer or bears" a day, and "wild honey, chestnuts and bilberries" were gathered in nearby forests. Despite grueling labor, the Moravians spoke of the gospel constantly. "Twice a day they gathered for worship, and the Scriptures were translated into the Mahikan language." (Postcard courtesy of Glenn Finsel.)

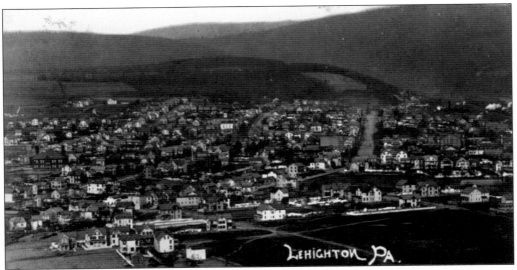

LEHIGHTON LANDSCAPE. Rev. John Heckewelder, Moravian missionary, studied the Lenni Lenape Indians extensively. In 1746, he wrote, "They think that he (the Great Spirit) made the earth and all that it contains for the common good of mankind. Whatever liveth on the land, whatsoever groweth out of the earth, and all that is in the rivers and waters . . . was given jointly to all." (Postcard courtesy of Clarence Getz.)

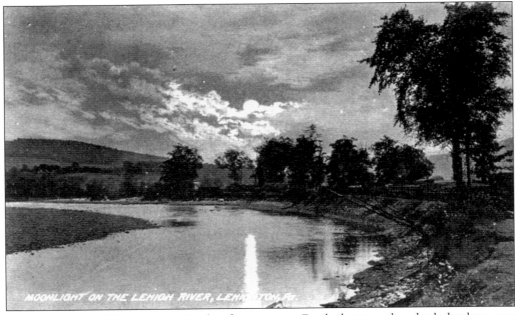

LEHIGH RIVER, NIGHTFALL. In the forests near Gnadenhutten, the rhododendron was bountiful, and the "land was covered with an evergreen called Sweet Fern." Sweet fern had a spicy and "agreeable odor, resembling bog-myrtle," but more subtle. The Moravians may have used a decoction of sweet fern to treat "summer complaint in children," and a pillow of its leaves was said to soothe an ailing child. (Postcard courtesy of Clarence Getz.)

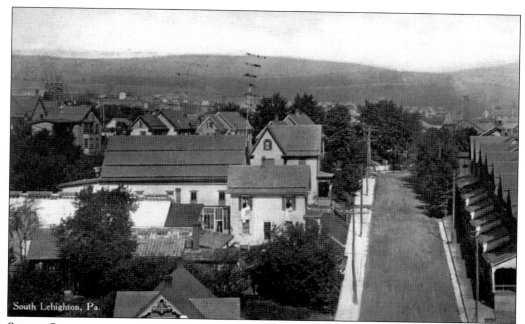

South Lehighton, Pa.

SOUTH LEHIGHTON, C. 1915. The desire to save even the "wildest of the wild race" compelled the Moravians to travel miles through undeveloped forests even in winter. A *c.* 1746 Moravian journal reads, "The snow lay on the ground a foot and a half deep. . . . We had great rocks and mountains to climb. One could see but little [or] none at all. We warmed ourselves a little walking, but were very tired, the snow being so deep." (Postcard courtesy of Clarence Getz.)

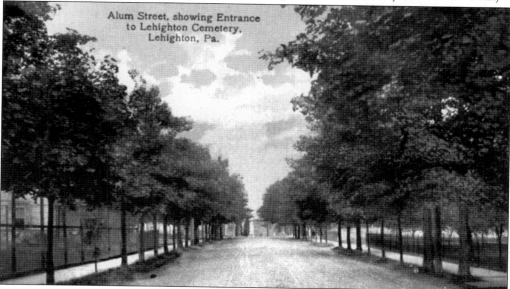

Alum Street, showing Entrance
to Lehighton Cemetery,
Lehighton, Pa.

ALUM STREET. The Six Nations Indians, particularly the Iroquois, resented the influence the Moravians had over the Indian converts. The Iroquois welcomed any opportunity to "weaken the influence of the brethren." In 1752, the Six Nations sent their "cousins," the Shawnee and Nanticoke Indians, to Gnadenhutten to covertly lay the groundwork for the return of the Lenni Lenapes and Mahicans back to Wyoming. (Postcard courtesy of Clarence Getz.)

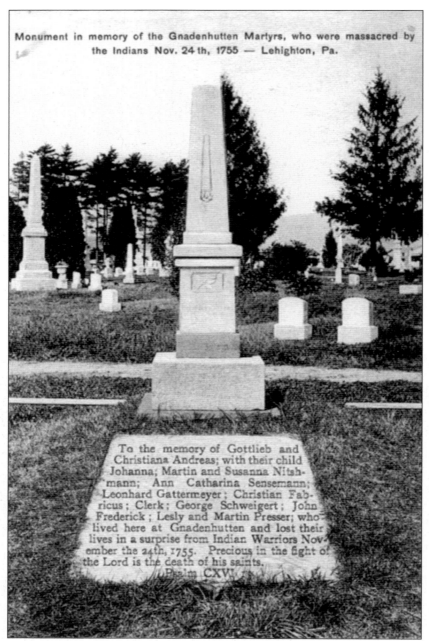

Monument in memory of the Gnadenhutten Martyrs, who were massacred by the Indians Nov. 24th, 1755 — Lehighton, Pa.

To the memory of Gottlieb and Christiana Andreas; with their child Johanna; Martin and Susanna Nitsh- mann; Ann Catharina Sensemann; Leonhard Gattermeyer; Christian Fab- ricus; Clerk; George Schweigert; John Frederick; Lesly and Martin Presser; who lived here at Gnadenhutten and lost their lives in a surprise from Indian Warriors Nov- ember the 24th, 1755. Precious in the fight of the Lord is the death of his saints. Psalm CXVI.

GOD'S ACRE. The Moravians hosted love feasts for visiting Shawnee and Nanticoke Indians. Typical fare was venison *sapan* (soup) and Welsh corn that was baked in bear fat. These gatherings included hymn sings and discourses on the scriptures. By the summer of 1752, a treaty of friendship between the Moravians and the Shawnee and Nanticokes was exchanged at the foot of the Blue Mountains with the exchange of wampum. Months later, the Shawnee and Nanticokes were sent to deliver a message to the Moravians from the Six Nations to compel them to return the convert Indians. "If they will not hear we would set their houses on fire and send musket-balls through their heads." (Postcard courtesy of Clarence Getz.)

14

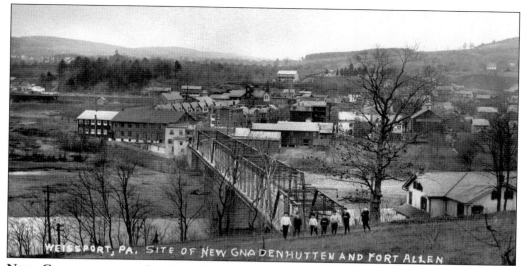

NEW GNADENHUTTEN. In 1753, final negotiations for the return of the American Indian converts to Wyoming took place in Bethlehem and Gnadenhutten. Complicated alliances and linguistics made it hard to reach an understanding. The Moravians made the following statement: "We should not clasp the arms and hold on to the Indians in Gnadenhutten, but separate them far apart, so that they could go to Wyoming if they wanted." The first step toward separation was the establishment of a new Gnadenhutten in 1754. (Postcard courtesy of Glenn Finsel.)

MARTYRS' MONUMENT. On November 24, 1755, eleven Moravians still residing at the old site of the original Gnadenhutten were massacred by a band of Assinnissink Indians led by Jachebus, their chief. The Moravians were attacked while "all were at supper." Some were shot; others died in "flames of fiery light." The flat stone that marks the mass grave in the Lehighton cemetery follows the Moravian custom of "laying breast-stones" on spots of interment. (Postcard courtesy of Clarence Getz.)

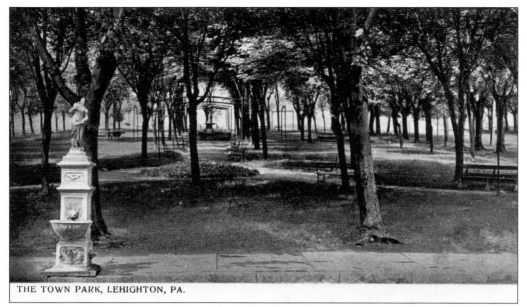

THE TOWN PARK, LEHIGHTON, PA.

LEHIGHTON PARK, C. 1910. Over a century after the Moravians settled in Lehighton, with Gnadenhutten gone, the cool shade of lower Lehighton Park beckons to all that pass. "There is something infinitely healing in the repeated refrains of nature . . . that dawn comes after night, and spring after winter." (Rachel Carson.) (Postcard courtesy of Nancy Shaffer.)

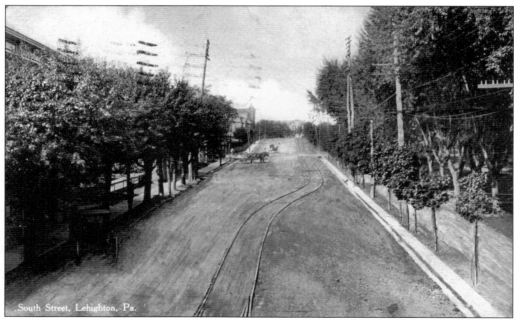

South Street, Lehighton, Pa.

ANOTHER VIEW, C. 1910. On South Street, along Lehighton Park, the large trees are lush, and the leaves are "made thick by midsummer." (Henry James.) No parking meters line the downtown area of Lehighton as of yet. The park was a quiet haven for pedestrians, providing cool walking and well-laid-out paths for strolling. (Postcard courtesy of Nancy Shaffer.)

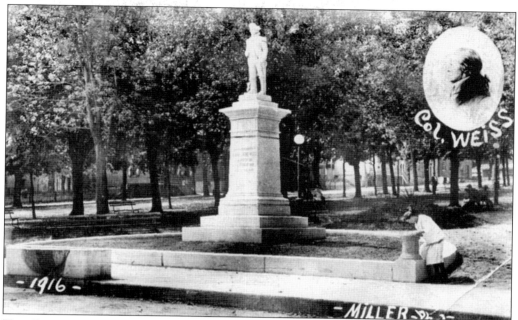

THE JACOB WEISS STATUE, SEPTEMBER 25, 1916. Seventy-seven years after the death of Col. Jacob Weiss, founder of Lehighton, a statue of him was unveiled at Lehighton Park during Old Home Week. Gertrude Sweeny, age 15, daughter of Mr. and Mrs. Harry Sweeny of Stroudsburg, was "introduced as the youngest descendant of Colonel Weiss, the donor of parks, to those in attendance." (Postcard courtesy of Clarence Getz.)

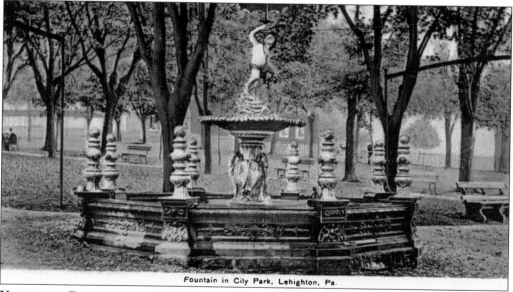

Fountain in City Park, Lehighton, Pa.

VICTORIAN FOUNTAIN, C. 1917. "Once I sat upon a promontory, and heard a mermaid on a dolphin's back. And certain stars shot madly from their spheres, to hear the sea-maid's music." (William Shakespeare.) At the center of Lehighton's lower park, a stunning baroque fountain is the focal point. Hypnotic and mesmerizing, the sight and sound of cascading water can certainly transcend and inspire. (Postcard courtesy of Clarence Getz.)

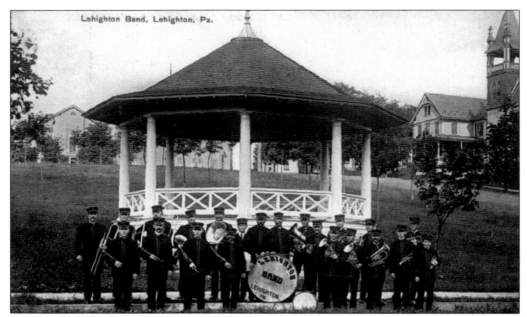

THE LEHIGHTON BAND, 1900. The Lehighton Band was organized in 1863. At the time of this photograph, music like John Philip Sousa's "Semper Fidelis" had replaced the somber Civil War anthems. This photograph shows the band members, dignified in their tailored uniforms, posing on Second Street at the bandstand. These award-winning musicians still give summer concerts in the park and march in parades, as they have done for over a century. (Postcard courtesy of Clarence Getz.)

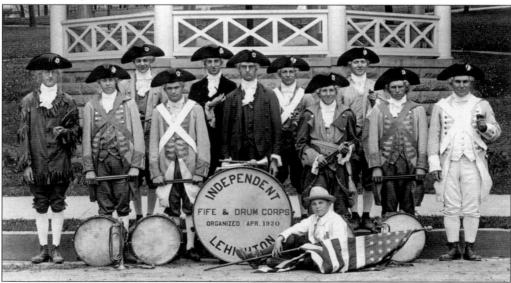

FIFE AND DRUM. This postcard depicts the Lehighton Fife & Drum Corps of 1920. Occupying an important role in military history, fife and drum corps were relied on to keep time for troops marching to war—a scenario all too familiar to Walt Whitman, who wrote the following in *Leaves of Grass:* "How your soft opera-music changed, and the drum and fife were heard in their stead." (Postcard courtesy of Hilbert Haas.)

18

TWO HOTELS, LEHIGHTON, *C. 1907*. In this view of Lehighton's downtown, we see the Carbon House, photographed from the vicinity of the Exchange Hotel, approximately a block away. Some of the same buildings still remain on First Street, but the original architecture is now obscured by modern facades. (Postcard courtesy of Clarence Getz.)

THE ALVENIA GRAVER MILLINERY. Milliners of the early 1900s offered more than hats; additional accessories were also sold, including hosiery, undergarments, aprons, muffs, gloves, and sometimes slippers and jewelry. Milliners like Alvenia Graver needed to keep informed about the latest fashions, and they also needed to know about sewing and the care of fine lace and linens. (Card courtesy of Nancy Shaffer.)

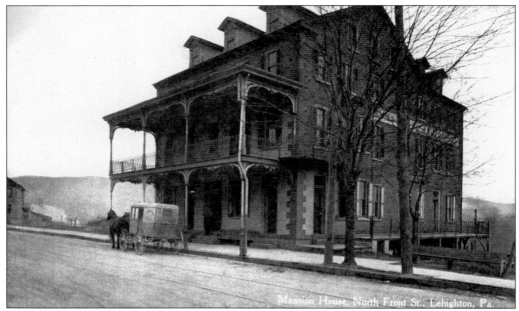

THE MANSION HOUSE. "When I was at home I was in a better place; but travelers must be content." (William Shakespeare.) The Mansion House, in Lehighton, was built by J. A. Horn in 1879. Located on North Front (First) Street in Lehighton, it was farther than most Lehighton hotels from the Lehigh Valley Railroad station but was still accessible on the heavily traveled road to Mauch Chunk. (Postcard courtesy of Nancy Shaffer.)

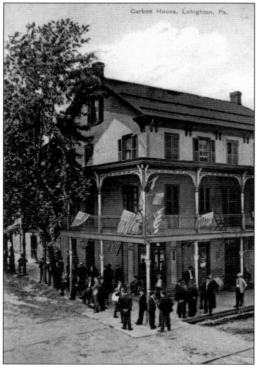

THE CARBON HOUSE, C. 1910. This postcard view depicts the Carbon House, a hotel located on First and North Streets, which was patronized for years by employees of the Lehigh Valley Railroad. The Carbon House, built in the mid-1800s, is no longer standing but figures prominently in the Franz Kline painting *An Artist's View of Lehighton,* located at the Lehighton Legion Home. (Postcard courtesy of Hilbert Haas.)

LEHIGH STOVES. The first anthracite-burning stove for home use was patented by Dr. Eliphalet Nott, of Novelty Iron Works, in 1844. Nott was a clergyman and founder of Brown University. This *c.* 1899 trade card advertises the Lehigh range. Coal heat is known for its properties of warmth and comfort. (Postcard courtesy of Nancy Shaffer.)

Aladin and the Wonderful Lamp: The Sultan seeing the Wonderful Castle.

If You want to enjoy Life, buy a LEHIGH STOVE

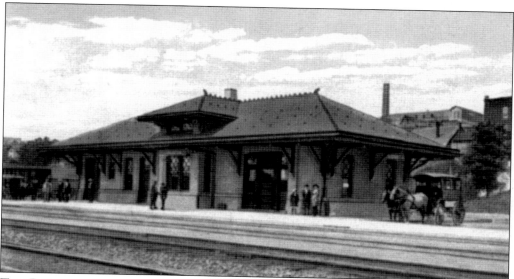

THE RAILROAD STATION. The Lehigh Valley Railroad station was located along what is now Sergeant Stanley Hoffman Boulevard. In 1855, the Lehigh Valley's trains ran daily from Easton to Mauch Chunk, stopping in Lehighton. On February 3, 1961, the Lehigh Valley Railroad retired the New York–Lehighton passenger train, the John Wilkes, making passenger service in Lehighton a thing of the past after 106 years. (Postcard courtesy of Hilbert Haas.)

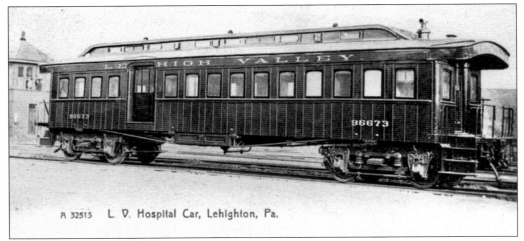

A 32513 L. V. Hospital Car, Lehighton, Pa.

THE LEHIGH VALLEY RAILROAD HOSPITAL CAR. The Lehigh Valley Railroad assisted America's soldiers during wartime by transporting soldiers and supplies. The hospital car was unique in that it was privately owned; most hospital trains were owned by the military. This well-equipped car contained everything for a basic field hospital, including an operating table and surgical tools. (Postcard courtesy of Clarence Getz.)

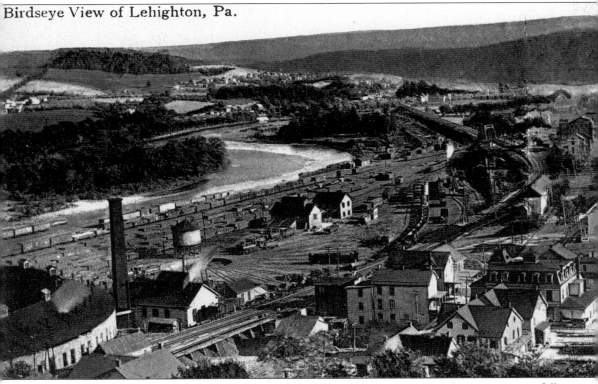

Birdseye View of Lehighton, Pa.

A LEHIGHTON PANORAMA, C. 1910. Lehighton's Moravian legacy is "one long epic poem, full of action, suffering, battle, bereavement . . . and the dauntless . . . spirit which bore these gentle ministers along their high careers." Although centuries have passed since the Moravians walked

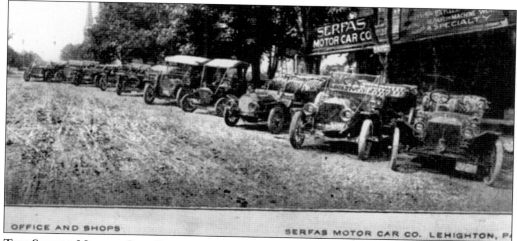

OFFICE AND SHOPS · SERFAS MOTOR CAR CO. LEHIGHTON, PA

THE SERFAS MOTOR CAR COMPANY. The Serfas Motor Car Company was located at 120 Iron Street in Lehighton and had the finest and most up-to-date motorcars in the county. Theodore A. Serfas opened up his car business in 1912. In addition to motorcars, the company sold and serviced bicycles. Sadly, this prominent business was ruined by fire on May 23, 1918. (Postcard courtesy of Clarence Getz.)

with the Lenni Lenape and Mahican Indians in the Blue Mountains, the Lehighton landscape still holds the soft shape of their moccasins and a time when the "Indian's foot alone knew the hidden paths that led from wigwam to wigwam." (Postcard courtesy of Nancy Shaffer.)

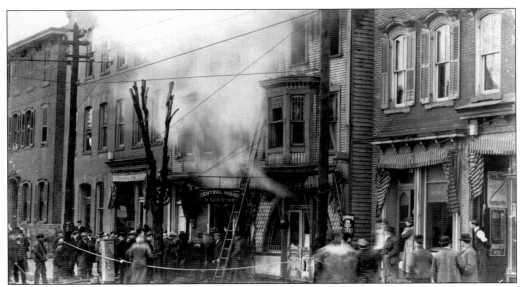

THE LEHIGHTON FIRE COMPANY, EARLY 1900S. "Lehighton's earliest fire company was organized on August 24, 1874. It had fifty charter members. H. V. Morthimer was chosen president; C. F. Horn, Secretary and P. T. Bradley, Fire Chief. Morthimer and Horn were the prime movers in the undertaking." (Brenckman.) Lehighton firefighters have upheld a strong tradition of steadfast service for over a century. (Postcard courtesy of Clarence Getz.)

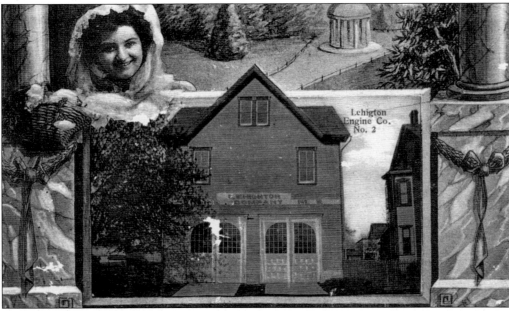

LEHIGHTON ENGINE COMPANY NO. 2. "Fancy a seething, roaring whirlpool of white heat covering more than an acre of ground . . . and you have the task [to put it out] with a single stream of water no larger than a lady's wrist." (*Issaquah Independent*.) The Lehighton Fire Company has entire families (such as the Nothsteins, second- and third-generation firefighters) in its organization. All members are volunteers who make tremendous sacrifices in time and safety. (Postcard courtesy of Richard Funk.)

24

TRINITY LUTHERAN CHURCH, C. 1900. "The congregation of Trinity Evangelical Lutheran Church (Third and Iron Sts.) was organized on Jan 5, 1873 by Rev. D. K. Kepner. The corner stone of the building was laid on the first of June of that year. Rev J. H. Kuder has been the pastor of this church since 1882." (Brenckman.) (Postcard courtesy of Clarence Getz.)

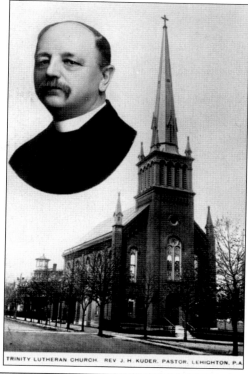

TRINITY LUTHERAN CHURCH. REV. J. H. KUDER. PASTOR. LEHIGHTON, P.A

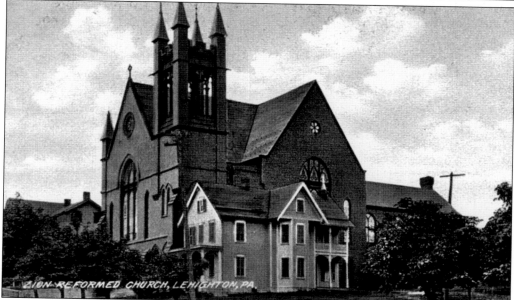

ZION REFORMED CHURCH, LEHIGHTON, PA

ZION REFORMED CHURCH, SECOND STREET. "Zion's Reformed congregation was organized on April 29, 1893, the meeting for that purpose having been held in the building of the Carbon Academy. All of the charter members were connected with Jacob's Church at Weissport prior to the forming of the new congregation. Rev. Abraham Bartholomew was the first pastor." (Brenckman.) (Postcard courtesy of Clarence Getz.)

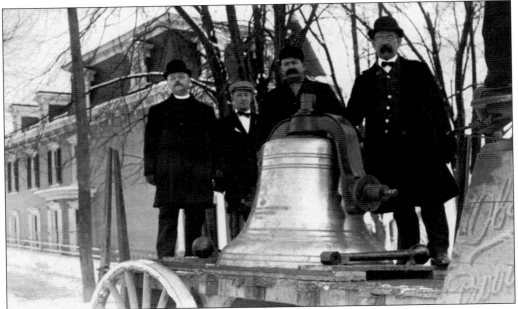

THE TRINITY EVANGELICAL LUTHERAN CHURCH BELL. The Latin phrase *Vivos voco, mortuos plango,* a popular inscription on church bells during the 18th and 19th centuries, translates as "I call the living, I mourn the dead." This *c.* 1908 postcard shows Rev. J. H. Kuder (left), George Acker, and others returning the Trinity Evangelical Lutheran Church bell to its rightful place to do its bidding. (Postcard courtesy of Clarence Getz.)

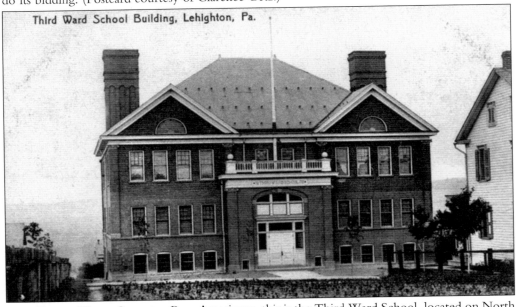

Third Ward School Building, Lehighton, Pa.

THE THIRD WARD SCHOOL. Pure Americana, this is the Third Ward School, located on North Fourth Street in Lehighton. The epitome of modern architecture in the late 1800s, the design of this Lehighton School went out of style, only to come back again. The building is of brick construction, with many intricate nooks and crannies; it has since become a commercial establishment. (Postcard courtesy of Clarence Getz.)

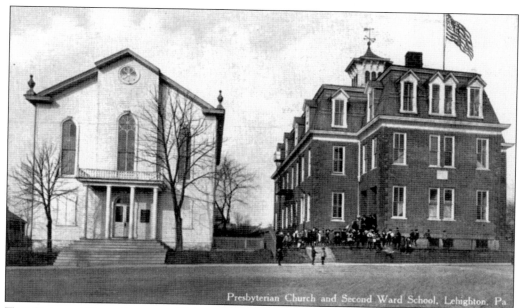

Presbyterian Church and Second Ward School, Lehighton, Pa.

THE SECOND WARD SCHOOL. This *c.* 1907 postcard shows Lehighton High School from North Street. Located next to the Presbyterian church, this building, with its beautiful mansard roof and cupola, has an understated elegance. The schoolchildren in the yard and American flag give this antique postcard the quintessential look of American schools from that era. (Postcard courtesy of Clarence Getz.)

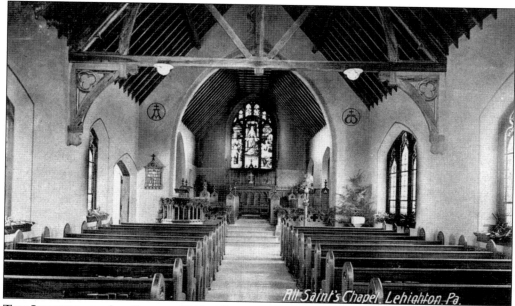

All Saint's Chapel, Lehighton, Pa.

THE INTERIOR OF ALL SAINTS, 1910. All Saints Episcopal Church in Lehighton was built by the benevolent Mary Packer Cummings, daughter of Asa Packer. Cummings belonged to St. Mark's Episcopal Church, All Saints' sister church in Mauch Chunk, where she resided. The dedication of the Lehighton church was held on September 20, 1907. The church and vicarage are constructed of "gray stone quarried at Bowmanstown." (Postcard courtesy of Nancy Shaffer.)

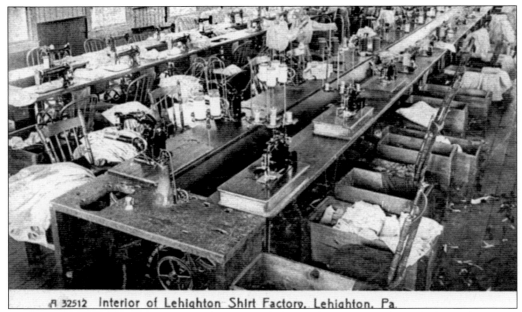

A 32512 Interior of Lehighton Shirt Factory, Lehighton, Pa.

A LEHIGHTON SHIRT FACTORY. This postcard shows the interior of a Lehighton factory in 1907. This mill provided modern equipment and was clean, warm, and well lit. Factories were a major employer of women at this time. "Work began at five o'clock on summer mornings, and at daylight in the winter. The . . . noon meal was from a half to three quarters of an hour." (*The Lowell Mill Girls.*) (Postcard courtesy of Clarence Getz.)

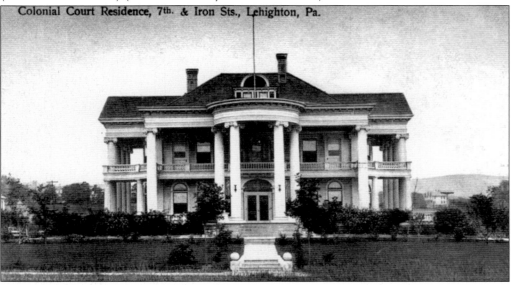

Colonial Court Residence, 7th. & Iron Sts., Lehighton, Pa.

COLONIAL COURT, 1901. "All the triumphs of the spirit . . . the skilled hands of labor . . . treasures of science [and] witcheries of art . . . are gathered here to . . . delight . . . the ever striving . . . mind of man." (John Hay.) This palace was owned by T. A. Snyder, Esq., who brought it to Iron Street from the Pan American Exposition in Buffalo, New York. The former "Michigan Building," with stunning Grecian architecture of Ionic columns and colonnades, awed the crowds in Buffalo and the residents of Lehighton. (Postcard courtesy of Clarence Getz.)

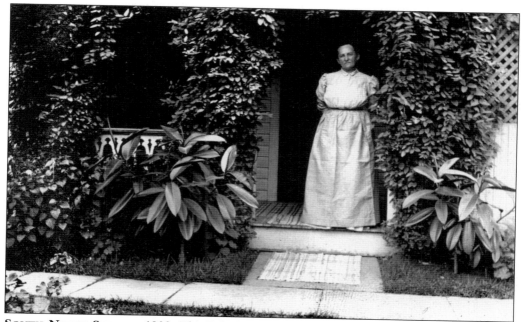

SOUTH NINTH STREET, 1908. This Lehighton real-photo postcard is a testament to the well-ordered homes of Carbon County in the 19th century. From the plush greenery, well-ironed apron, and handmade rag rugs, many of the women of this era were occupied with being good housekeepers. "Industry and frugality made proper amends for whatever might be deficient." (Postcard courtesy of Barbara Gelatko.)

Pa is Going to take Us to the
Great Lehighton Fair
Lehighton, Pa., Sept. 26-29

THE LEHIGHTON FAIR. Organized by the Carbon County Agricultural Society to promote agriculture, the Lehighton Fair was held annually at the fairgrounds in the west end of town. The fairgrounds became synonymous with local aviation due to ample landing areas for small planes. Father and son Byron and Jake Arner, along with Fred Getz of the Lehighton area, are the first names in Carbon County aviation. (Postcard courtesy of Glenn Finsel.)

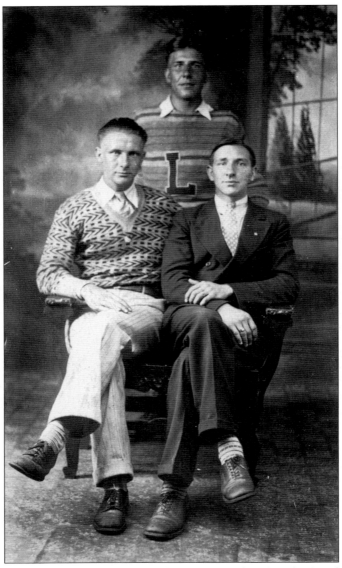

THE ARTIST FRANZ KLINE, 1928. Renowned artist Franz Kline (standing) and his friends Portz (left) and Henry Bretney pose for a photograph at Fortress Monroe, Maryland. At this age, Kline (a junior at Lehighton High School) never never imagined that he would change art history with his large abstract works or be offered Yale's prestigious "Chair of Art." (Interview with Dr. Louise Kline-Kelly.) Kline's works grace the walls of all major museums in the world. But for Kline, the mark of success was more personal. "The final test of a painting," he stated, "is: does the painter's emotion come across?" Kline lived on South Ninth Street in Lehighton with his mother, Anne, from Cornwall, England, and his stepfather, a Pennsylvania Dutch railroad supervisor. Kline was fascinated by trains, especially the Lehigh Valley Railroad's Black Diamond. His painting *Diamond* underscores this fascination. The title of Kline's works indicate the importance that Lehighton and Carbon County as a whole held for him. Franz and his colleagues Jackson Pollock and Willem DeKooning were the innovative abstract painters of the New York school. (Postcard courtesy of the author.)

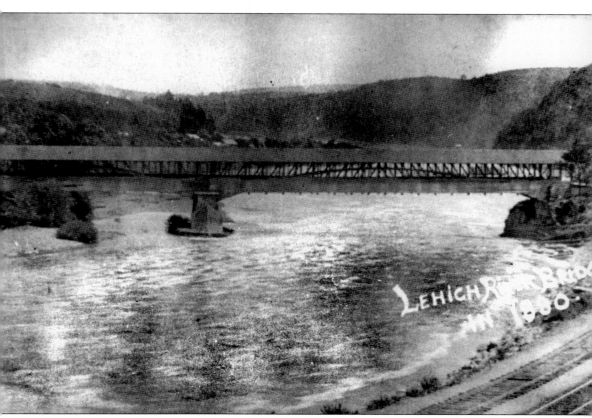

WEISSPORT BRIDGE, C. 1880. In January 1756, two months after the massacre at Gnadenhutten, 40 militia guarding the Moravian settlement of New Gnadenhutten were ambushed on this frozen river. The result was 40 dead soldiers and "forts extending from Kittatinny (Blue Mountains) and the Delaware River to the Maryland line," guarding the most important mountain passes. After the tragic massacres of the Moravian brethren, the soldiers, and others, Gov. Robert Morris sent Benjamin Franklin and his militia to the site of New Gnadenhutten with orders to erect a stockade. Because of its "commanding and central location," Fort Allen was considered the most important fort along the "Blue range, ten miles above Lehigh Gap." In addition to being the site of Fort Allen, Weissport has a rich history that includes a proximity to the Lehigh Canal, with a portion of this "well preserved piece of historic waterway" right in Weissport's backyard. The Lehigh Canal Park, in Weissport, is part of Pennsylvania's National Heritage Corridor. Along the wooded towpath, the easy spirit of old canal life still permeates this quaint and beautiful place.

Weissport, Union Hill and Lehighton. "On the waters of the upper Lehigh, among the people who then sat themselves down in that region of hidden and unsuspected wealth was Col. Jacob Weiss who had served his country as an officer in command of continental troops." The village of Weissport looks much like it did over a century ago. The second oldest settlement in Carbon County, it is named for its founder, Col. Jacob Weiss. This postcard also shows the back of the small village of Union Hill. (Postcard courtesy of Linda Hunsicker.)

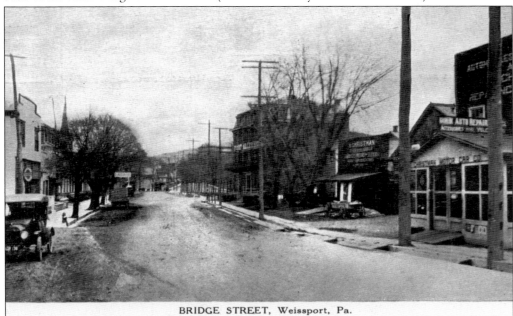

BRIDGE STREET, Weissport, Pa.

Bridge Street. This postcard shows Bridge Street in Weissport, the site of the original Fort Allen (now the Fort Allen House), "a place of refuge in times of Indian depredations and for years occupied by a handful of rangers and scouts." Assigned to construct a stockade in 1756, Ben Franklin took on the higher purpose of bringing peace and order in the face of the chaos and panic unleashed by the American Indians' violence. He wrote, "I undertook this military business though I did not conceive myself well qualified for it." (Postcard courtesy of Nancy Shaffer.)

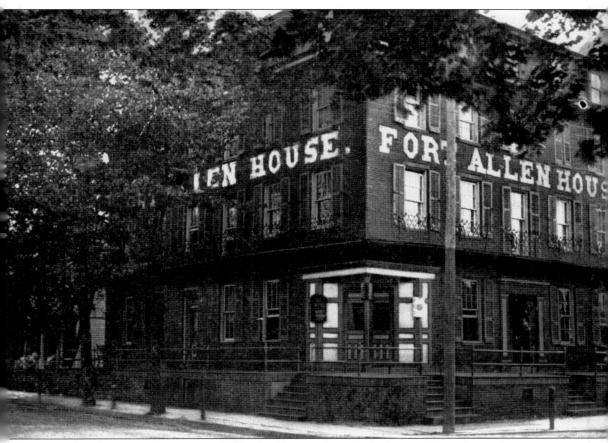

THE FORT ALLEN HOUSE, C. 1915. On his way from Bethlehem to New Gnadenhutten in 1756, Ben Franklin wrote, "I concluded to go myself with the rest of my forces to [New] Gnadenhutten where a fort was thought more immediately necessary. The Moravians procured me five wagons for our tools, stores, and baggage. Just before leaving Bethlehem eleven farmers . . . driven from their plantations by the Indians came to me requesting a supply of firearms that they might go back and bring off their cattle. I gave them each a gun with suitable ammunition. We had not marched many miles before it began to rain and continued raining all day. There were no habitations . . . to shelter us." Later, Franklin received word that 10 of the 11 farmers were killed by the American Indians when "their guns would not go off, the priming being wet with the rain." The next day, Franklin and his men arrived at "desolate Gnadenhutten." "Our first duty," says Franklin, "was to bury more effectually the dead we found there who had been half interred by the country people." (Postcard courtesy of Nancy Shaffer.)

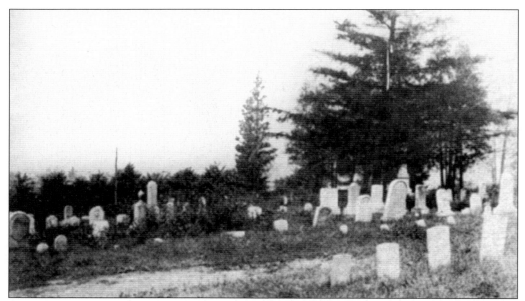

FRANKLIN HEIGHTS CEMETERY. Jacob Weiss, founder of Weissport, donated the land for the Franklin Heights Cemetery in 1839 and became the first to be buried there. Weiss came to Carbon County in 1784, after traveling the Lehigh River valley speculating land. While on the Lehigh River, the dense timberland appealed to his entrepreneurial spirit; he purchased 700 acres from the Moravians to run a sawmill. (Postcard courtesy of Clarence Getz.)

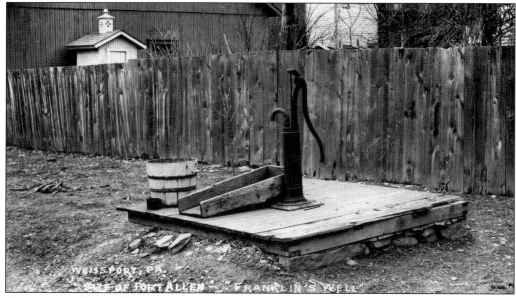

FRANKLIN'S WELL. This well, which was built by Ben Franklin's soldiers at Fort Allen, is the only part of the fort that remains. In 1756, Franklin wrote, "Our carpenters built a platform of boards all round within . . . six feet high for the men to stand on when to fire through the loop holes. We had one swivel gun [and] fired . . . to let the Indians know . . . we had such pieces." To the governor, he wrote, "This day we hoisted your flag . . . and nam'd the place Fort Allen." (Postcard courtesy of Glenn Finsel.)

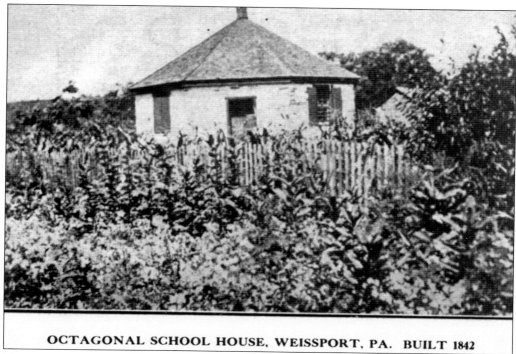

OCTAGONAL SCHOOL HOUSE, WEISSPORT, PA. BUILT 1842

THE OCTAGONAL SCHOOLHOUSE. This odd-shaped school was built in 1842 in Weissport. "The philosophy of octagonal-shaped school buildings can be traced to a Quaker tradition." Believing that an octagon shape would provide an atmosphere more conducive to learning, the teacher would maintain position in the center of the room. This school had thick walls and for a time was used as a jail. (Postcard courtesy of Linda Hunsicker.)

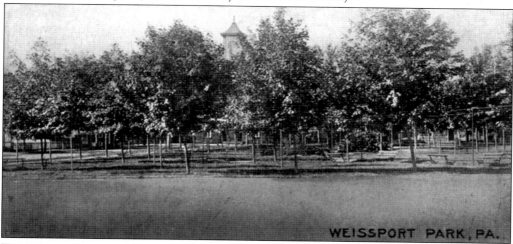

WEISSPORT PARK, PA.

WEISSPORT PARK AND JACOB'S UNITED CHURCH OF CHRIST. As the land in Weissport and Franklin Township became inhabited, there was greater security, and American Indian attacks "soon were ceased entirely, farms were hewed out of the forests, passable roads were laid over the warriors paths, and St. Anthony's Wilderness became prosperous." Weissport Park, shown in this *c.* 1899 postcard, is still beautiful with trees and the familiar sight of the Jacob's United Church of Christ steeple touching the sky. (Postcard courtesy of Clarence Getz.)

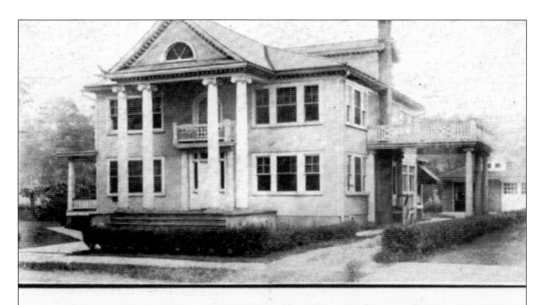

Residence and Office of C. P. Haberman, M. D., Weissport, Pa.

THE MAYES-MELBER FUNERAL HOME. The former residence of Dr. C. P. Haberman is still stunning with its Greek Revival architecture and quiet sophistication. It is the neighbor of the oldest church in the Weissport area, Jacob's United Church of Christ. Jacob's was built in 1839, and the first congregation, although not Moravian per se, was "an outgrowth of the Gnadenhutten Mission," according to early historians. (Postcard courtesy of Clarence Getz.)

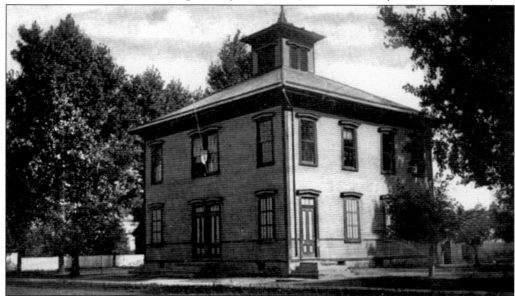

OLD WEISSPORT SCHOOLHOUSE. Prior to 1822, Weissport and Franklin Township children attended school in Weissport in the school building constructed by the Moravians on the site of the old Moravian settlement. Moravian artisans fashioned their school bell out of brass themselves. Sources indicate that the wooden schoolhouse on this postcard was built in 1865 on the same site as the octagonal stone school building shown previously. (Postcard courtesy of Clarence Getz.)

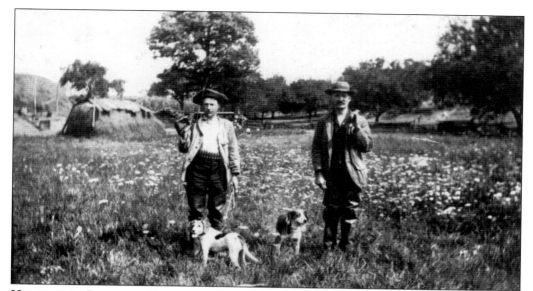

HUNTING IN FRANKLIN TOWNSHIP. "We are ancients of the earth and in the morning of our times." (Alfred Lord Tennyson.) Two Franklin Township men, Elmer Dreisbach (left) and Thaddeus Kresge, hunt with their canine companions on this real-photo postcard from 1880. This picture shows Franklin Township's lush agricultural landscape over 100 years ago. (Postcard courtesy of Linda Hunsicker.)

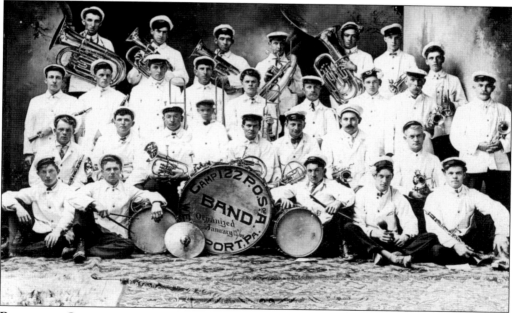

PATRIOTIC ORDER OF THE SONS OF AMERICA BAND, WEISSPORT, C. 1910. After the Civil War, grassroots fraternal organizations such as the Odd Fellows, the Patriotic Order of the Sons of America, and the Improved Order of Red Men were over 250 strong. This postcard shows the Camp 122 Patriotic Order of the Sons of America Weissport Band. Many fraternal groups are still thriving, though the Patriotic Order of the Sons of America has lost much of its membership. Many old graves still bear their flag holders. (Postcard courtesy of Nancy Shaffer.)

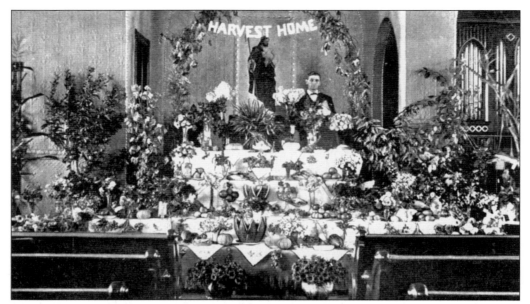

HARVEST HOME, JACOB'S UNITED CHURCH OF CHRIST. "These delicates he heap'd with glowing hand, On golden dishes and in baskets bright, Of wreathed silver: sumptuous they stand, In the retired quiet of the night." John Keats could have been speaking of the bounty of Jacob's United Church of Christ in his poem "The Eve of St. Agnes." Seen on this postcard from 1899 is the interior of the church. The original congregation worshiped outdoors until 1838, when Col. Jacob Weiss donated the parcel of land on which the church is built. (Postcard courtesy of Nancy Shaffer.)

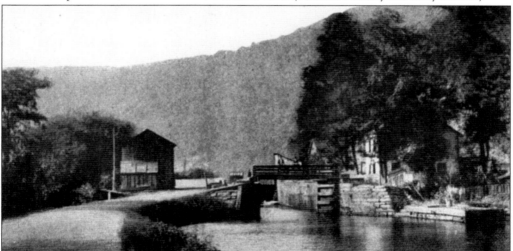

AN EARLY CANAL VIEW. The foresight and tenacity of Josiah White and Erskine Hazard, builders of the Lehigh Canal, defied the defeatist opinions of men such as Col. James Burd, who after arriving in Weissport said, "I arrived on the top of the mountain, I could see a great distance on both sides of it; the northern part of the county is an entire barren wilderness, not capable of improvement." White and his men worked chest deep in the Lehigh River constructing 20 dams and 29 dry stone locks capable of lifting tons of coal 30 feet. Sluice gates of a "peculiar design" were also invented by White in his quest to improve the navigation of the Lehigh River. (Postcard courtesy of Clarence Getz.)

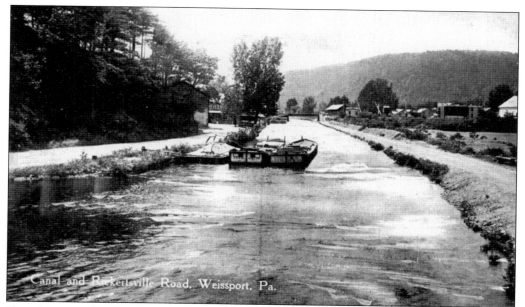

THE CANAL. After his relocation from Philadelphia to Weissport, Col. Jacob Weiss busied himself with the process of turning "these savage haunts into the peaceful abodes of civilized life," never imagining that the discovery of anthracite coal in 1791 would transform this valley into a major part of progressive river navigation in America. (Postcard courtesy of Nancy Shaffer.)

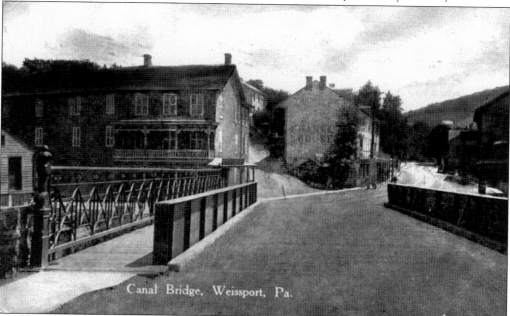

THE CANAL BRIDGE, WEISSPORT. The canal bridge marks the edge of town where the railroad crossing still protects the trains' rightful passage as traffic comes to a halt. This is where Weissport comes alive and where the wanderlust and fascination of transportation are like static in the air, blowing cool at this intersection of the Lehigh Canal and the Pennsylvania Railroad. (Postcard courtesy of Clarence Getz.)

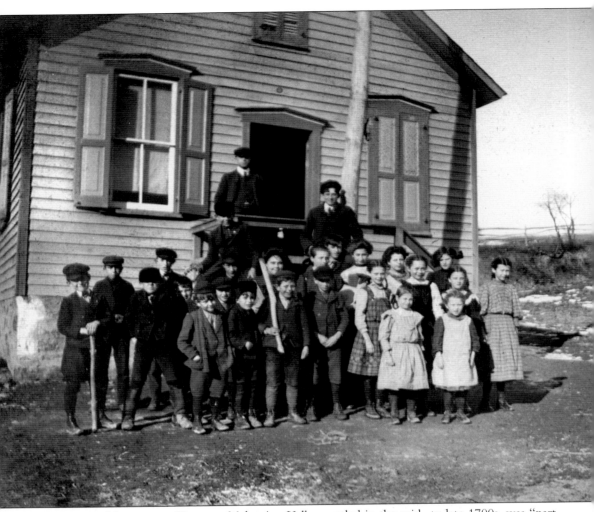

HISTORIC MAHONING VALLEY. Mahoning Valley, settled in the mid- to late 1700s, was "part of the first settlement by the Moravians." Ironically, as new settlers arrived, many residents were fleeing because of American Indian attacks and the Gnadenhutten massacre. George Washington, 23 years old at the time, described his personal reaction to the settlers' terror of American Indians as follows: "The supplicating petitions of the men and the tears of the women melt me into such deadly sorrow that, for the people's ease, I could offer myself a willing sacrifice to the butchering enemy." The Mahoning Schoolhouse No. 3 is shown here about 150 years after the first settlers came to Mahoning Valley. American history, including that of the French and Indian War, was taught here by Calvin A. Sensinger. His history lessons would have included the saga of the Gilbert family, kidnapped by American Indians in 1780 from their Mahoning Valley home. "The premises where stood the dwelling and improvements of the Gilbert family were on the North side of Mahoning Creek on an elevated bank." Shown here in cap and tie, standing near the front door, Sensinger pauses with his students, one of whom is Mabel Wehr, to whom this photograph belonged. (Postcard courtesy of Leah Wehr.)

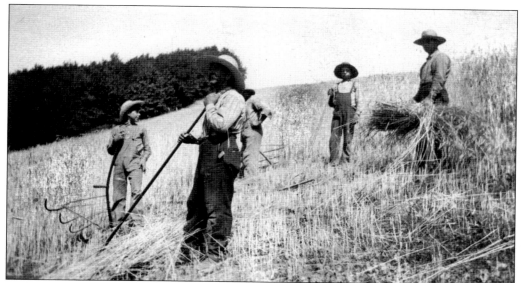

GRAIN HARVEST. "In April 1780, about sunrise, a party of eleven painted Indians issued from the woods bordering mahoning Creek and surrounded the log house of the old miller [John Gilbert] with tomahawk raised and flintlocks cocked. The old Quaker offered his hand as a brother. It was refused." Mahoning farmer Calvin Sensinger (rear) stands in the back field of his Mahoning Valley farm, just a few miles from where the Gilbert family was abducted 100 years before. (Postcard courtesy of Leah Wehr.)

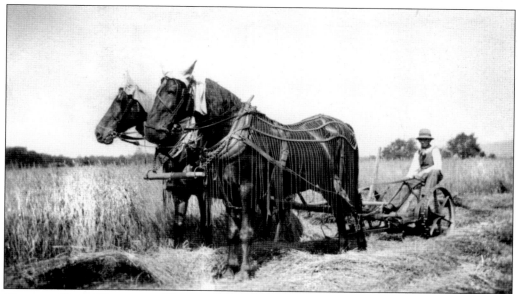

MOWING HAY, MAHONING VALLEY, 1900. This postcard of Sensinger's farm, located a few miles from the Gilberts' mill, shows the same low-slung hills and vast expanse of land owned by the Gilberts. "Taken by Indians [in 1780] were the patriarch of the household, Benjamin . . . sixty-nine years old; Elizabeth, his wife;" several children; and Abigail Dodson, who "had the ill-luck to come to Gilbert's mill that morning for grist, and was taken with the rest." (Postcard courtesy of Leah Wehr.)

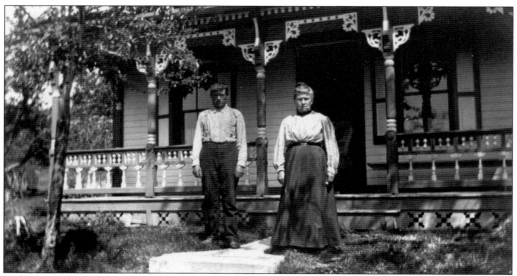

FARMHOUSE, C. 1900. Over 100 years after the Gilberts were captured, Mahoning Valley settlers lived in houses of clapboard rather than logs. The Gilberts, initially taken north from their log home by their captors, watched as "old Benjamin Gilbert was painted black, a custom of the Indians with prisoners they intended to kill." In captivity, their provisions were quickly depleted, and "a chance hedgehog, and roots dug in the woods, sustained them for some days." (Postcard courtesy of Leah Wehr.)

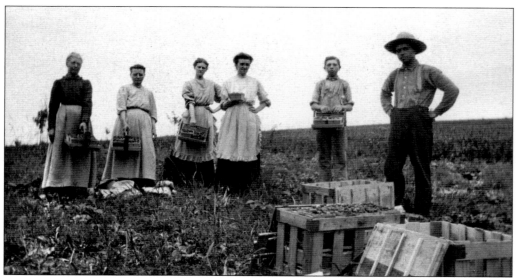

THE SENSINGER FARM, MAHONING VALLEY. In 1905, farmer Calvin Sensinger (right) no longer needs to fear American Indian attacks as he and his workers pick strawberries in Mahoning Valley, a luxury early settlers did not share. The leader of the Gilbert raiding party, Rowland Mountour, was half Indian and half American. When confronted with an attempted escape by young Jesse Gilbert, he threw Jessie to the ground and "lifted his tomahawk ready to raise the final blow." (Postcard courtesy of Leah Wehr.)

THE FLEXER FARM, MAHONING VALLEY.
Mahoning Valley farmland contained a
wealth of arrowheads enough for children
like Lewis Flexer (center) to fill their pockets.
The home of Benjamin Gilbert was not far
from the Flexer farm in Mahoning Valley;
Gilbert's home was vacant for two years.
Rebecca Gilbert was adopted by Chief
Rowland Montour's wife. The woman was
known as "the Princess" and "the grandest
Indian woman on the Niagara." (Postcard
courtesy of Leah Wehr.)

MAHONING VALLEY LANDSCAPE, 1900. Maude Beck, Pearl Ohl, and Mabel Wehr are not
much older in this photograph than Rebecca Gilbert was when she was adopted by Rowland
Montour's wife, an Indian princess "dressed in the Indian costume . . . shining with gold lace and
silver baubles." When Rowland Montour presented Rebecca to her, "the princess took a silver
ring from her finger and put it on Rebecca's which completed the adoption." (Postcard courtesy
of Leah Wehr.)

Pleasant Corner School,

DISTRICT NO. 3.

Mahoning Twp., Carbon Co., Pa.

Oct. 8, 1900—May 8, 1901.

PUPILS:

Harvey Zimmerman, Esther Kressley,
Claudius Zimmerman, Estella Heintzleman,
Robert Heintzleman, Alvin Flexer,
Harry Ohl, Robert Gumbert,
Warren Wehr, Annie Gilbert,
Lillie Mertz, Lydia Hontz,
Carrie Kressley, Ada Kistler,
Minnie Heintzleman, Warren Zimmerman,
Florence Kressley, Ida Gilbert,
Charles Zimmerman, Oscar Kistler,
Mary Lobien, Alvin Zimmerman,
Mabel Wehr, Mabel Kistler,
Ida Zimmerman, Minos Grow,
Cora Smith, Jemima Cunfer,
Clifford Kistler, Harry Sensinger,
Raymond Flexer, Martin Smith,
Mamie Zimmerman, Jennie Lobien.

Board of Education.

D. A. Rehrig, Samuel Zimmerman,
O. M. Heintzleman, Aaron Zimmerman,
Nathan Wehr, Nathan Mertz.

Prof. A. S. Beisel, County Supt.

Ida Sitler Teacher.

PLEASANT CORNER SCHOOL NO. 3. This is a memento of the 1900–1901 school year at Pleasant Corner School in Mahoning Township. The teacher that term was Ida Sitler. The board of education consisted of D. A. Rehrig, O. M. Heintzleman, Nathan Wehr, Samuel Zimmerman, Aaron Zimmerman, and Nathan Mertz. The county superintendent of schools was Prof. A. S. Beisel. (Postcard courtesy of Leah Wehr.)

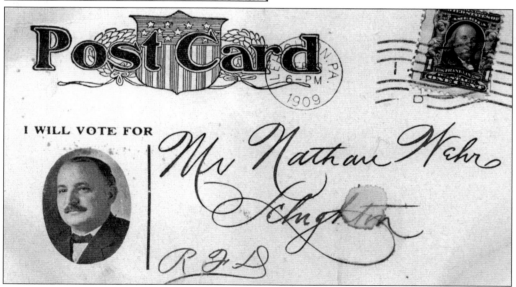

A CANDIDATE, 1909. This is a postcard campaigning for votes for Arthur B. Clauss of Mahoning Valley, for justice of the peace. It is postmarked February 9, 1909, just a few days before election day, which was February 16 that year. Although the card is postmarked Lehighton, New Mahoning had its own post office, established in 1850, with Tilghman Arner serving as postmaster. A post office was also established at Pleasant Corners, which was later moved to the Freyman Hotel. (Postcard courtesy of Leah Wehr.)

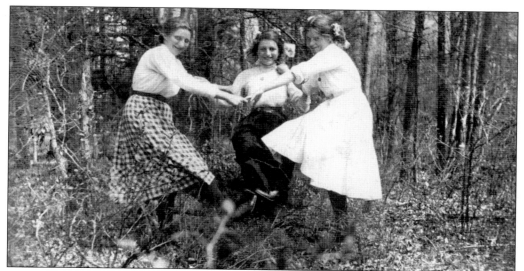

BAKE OVEN. "We dance around in a ring and suppose, but the secret sits in the middle and knows." (Robert Frost.) This photograph postcard was taken at the Bake Oven, along the Appalachian Trail, documenting a Saturday excursion for three friends and their unidentified chaperone in 1903. Playing for the camera are, from left to right, Mabel Wehr, Lulu Zimmerman, and Mary Erwin, friends from the Mahoning Valley School. (Postcard courtesy of Leah Wehr.)

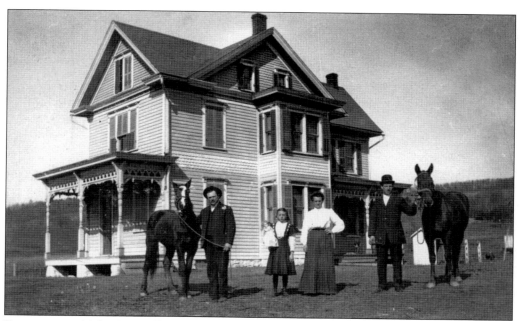

FARMHOUSE. Mahoning Valley was typically a farming area, but there were also residents who owned a variety of businesses. Thomas Walton had a general store, blacksmith shop, and hotel. Henry Arner opened a shoe factory to supply the miners at Summit Hill. This real-photo postcard not only depicts a family and their horses, it also captures the look of Mahoning Valley's architecture and landscape, as well as the fortitude of its hardy settlers. (Postcard courtesy of Leah Wehr.)

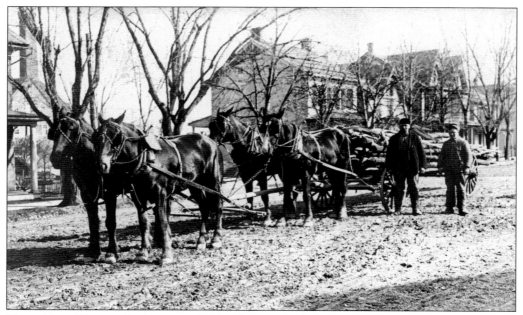

MAHONING VALLEY LUMBER, C. 1903. Alvin Wehr (left) and an unidentified man are shown with Wehr's team of horses and a large load of lumber brought from his Mahoning Valley farm. They are standing on Second Street in Lehighton across from where the Lehighton Hardware Store now stands. (Postcard courtesy of Leah Wehr.)

MAHONING VALLEY'S FUTURE. On the township's first assessment roll, some of the names were "John Ammon, clock maker and trader; Henry Arner, powder mill and saw mill; Jacob Fenstenmacher, innkeeper; Michael Garber, grist and saw mill; David Heller, tan yard; Reuben Hagenbuch, innkeeper." William A. Wehr, son of Mahoning Valley farmer Alvin Wehr, poses for a photograph in a local photography studio *c.* 1903. (Postcard courtesy of Leah Wehr.)

ADA ZELLNER. "I felt sure I was a favorite . . . he made every child that. We were absolutely fearless with him. . . . We felt he was one of us and on our side against all the grown ups." This quotation speaks of Lewis Carroll, author of *Through the Looking Glass* and photographer of Victorian children. Carroll's subjects included Hallam Tennyson, son of Lord Alfred, adults Christina and Dante Gabriel Rossetti, and Carroll's muse, Alice Liddell. This photograph of Ada Zellner from Carbon County, although not one of Lewis Carroll's creations, has a haunting quality similar to Carroll's best works, which can be found in the book *Dreaming in Pictures*. (Postcard courtesy of Leah Wehr.)

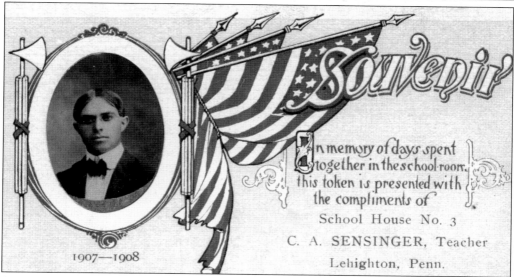

SCHOOL SOUVENIR. This fine antique postcard was a souvenir given by teacher Calvin A. Sensinger to his students in the 1907–1908 school year. "In memory of days spent, together in the school room, this token is presented with complements of School House No. 3, C.A. Sensinger, Teacher, Lehighton (Mahoning Valley) PA." The oval contains a photograph of Sensinger. (Postcard courtesy of Leah Wehr.)

CIVIL WAR HERO. As a conscientious objector, Nathan Wehr of Mahoning Valley was prepared to pay the $300 required to be exempt from fighting in the Civil War. When Wehr learned that his neighbor, a father of small children, could not afford an exemption, Wehr went in his place, enlisting on November 3, 1862. He served in the 173rd Regiment, Pennsylvania Volunteers, for almost one year. He was mustered out on August 18, 1863, and returned home to Mahoning Valley. Five men in the 173rd Regiment, Pennsylvania Volunteers—David Steigerwalt, Israel Sassaman, Reuben Hoffman, Fraley Breish, and John Keer—were killed in battle, the kind of tragedy expressed poignantly here by Walt Whitman: "And I saw askant the armies, I saw as in noiseless dreams hundreds of battle-flags, Borne through the smoke of the battles and pierced with missiles I saw them. . . . And the staffs all of the slain soldiers of the war, But I saw they were not as was thought, They themselves were fully at rest, they suffered not, The living remain'd and suffered, the mother suffered, And the wife and the child and the musing comrade suffered." (Postcard courtesy of Leah Wehr.)

Two

THE PROMISED LAND

*If we were millionaires we would procure for every one
a free excursion ticket to Mauch Chunk, so all could see and admire the
Switzerland of America. From whichever side this place is reached, a scenery
develops of which the equal is, perhaps, not to be found anywhere.*

—*Manufacturer & Builder*, June 1873

Like the stunning allegro of a Vivaldi concerto, Jim Thorpe is an opus to nature and the ingenuity of man. Situated along the Lehigh River, this "perfect wilderness" was once deemed "as unlikely a spot as could be selected for a town." The truism "geography is destiny" illustrates Jim Thorpe's place in the universe. Undeniably magnificent, the terrain of this place was a major detriment to the development of its resources, but the perseverance of two Quaker visionaries, Josiah White and Erskine Hazard, brought this struggle to a positive and profitable close.

Since the early 1800s, Jim Thorpe has been a retreat for travelers, adventurers, and bohemians, and a center for art, drama, and music, all in a setting that comes straight out of Dickens. With its idiosyncrasies and attractions, people are quickly smitten with Jim Thorpe, a place that has an eclectic mix of wonderful history and aesthetics, as well as the status that comes from being the county seat. Watson's 1857 *Annals of Philadelphia and Pennsylvania* described Jim Thorpe (formerly known as Mauch Chunk) as follows:

> On the opposite side of the Lehigh is a mountain, nine hundred feet in height and the canal along its base; near the bridge is a dam across the river. Everything in this region shows invention, so much so, that it looks like enchantment, and Josiah White himself is the great wizard.

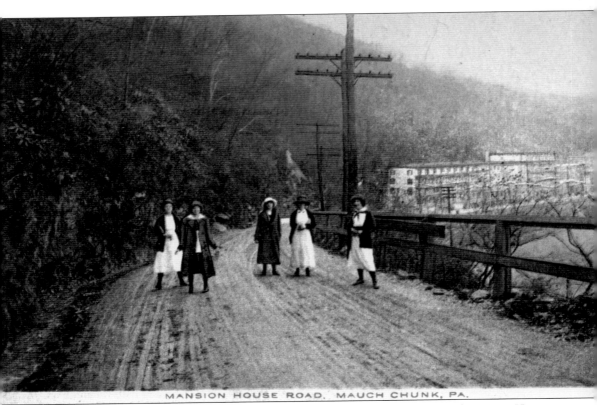

MANSION HOUSE ROAD, MAUCH CHUNK, PA.

MANSION HOUSE ROAD, C. 1907. Young ladies stand bravely in the middle of Mansion House Road (now Route 209). Named for the Mansion House, the monolithic structure—christened the largest hotel in America—looms in the background. Thirty years earlier, the view approaching Mauch Chunk was much the same (minus the light poles), as we read this elaborate description in *Some Highways and Byways of American Travel*, 1877: "The sweeping curve of the steep South Mountain forms the segment of a vast amphitheatre, from which the Titans might have watched gladiatorial giants in their fierce combats upon the lesser hill half encircled by the river. The wall rises to a sheer height of more than nine hundred feet, and is rendered more wild and picturesque by the outcroppings among its pines and hemlocks of rugged ledges and strange seams of rock. The great white Mansion House, loftily over towered by the dark mass of this mountain, appears at first glance like a toy dwelling, or the abode of Lilliputians." (Postcard courtesy of Fred Bartelt.)

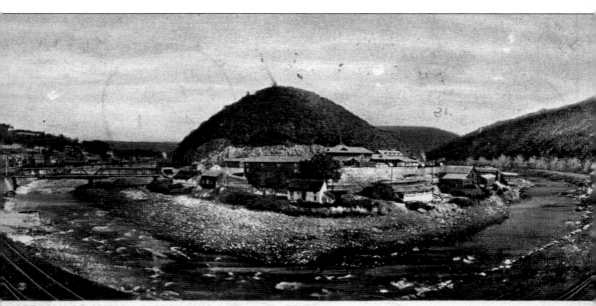

PANORAMA OF MAUCH CHUNK.

BEAR MOUNTAIN. Mauch Chunk comes from the Lenni Lenapian word *maskachiwink,* meaning "on the bear mountain." We see that mountain on this *c.* 1903 postcard. The Lehigh Canal is visible here as it hugs the circumference of the mountain's base. Visible, too, is the Lehigh River. The Lehigh River and its tributaries are great for angling. John James Audubon, who visited Mauch Chunk on his way to and from the Great Pine Swamp, was delighted with fishing in and around the Lehigh. The great naturalist spent six weeks in Carbon County and was impressed with the abundance of wild turkey, pheasant, and grouse, but even more so with the fishing, as "his angler's heart was beating with joy when he thought about the trout streams 'in the River Lehigh.'" "'Ah, Reader,' " exclaimed Audubon, "'if you are an angler do go there and try for yourself. For my part, I can only say that I have been made weary with pulling up from the rivulets, the sparkling fish allured by the struggles of the common grasshopper.'" (The *Living Age*.) (Postcard courtesy of Richard Funk.)

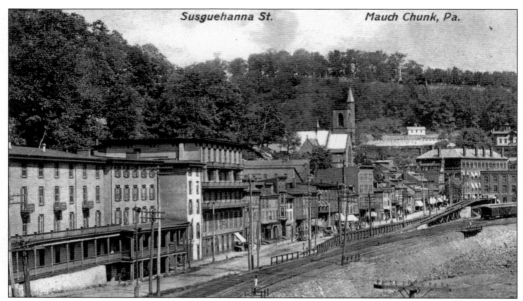

SUSQUEHANNA STREET. This early-1900s postcard shows the view approaching Mauch Chunk from Mansion House Road. Some of the Mansion House appears in the left forefront, though the hotel sign is mysteriously absent. Although the Mansion House remained open until 1929, the spirit of the hotel seems strangely absent from this picture. A portion of the Mansion House still exists as Highland Beverage. (Postcard courtesy of Fred Bartelt.)

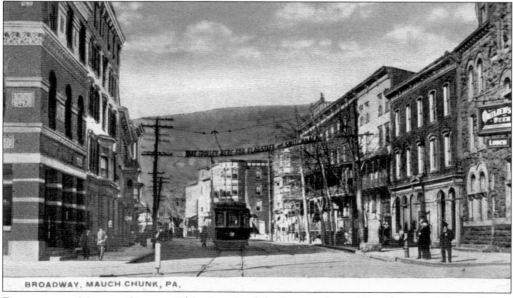

BROADWAY, MAUCH CHUNK. This view is of the intersection of Broadway and Susquehanna Street *c.* 1910. It shows the Navigation Building (left) and the Carbon County Courthouse. The beer sign belongs to the Central Hotel. How wonderful it would be to see this old banner advertising the Switchback Railroad and Flagstaff across Broadway again. The trolley service no longer exists, but otherwise this intersection remains very much the same. (Postcard courtesy of Juliana Rhodes.)

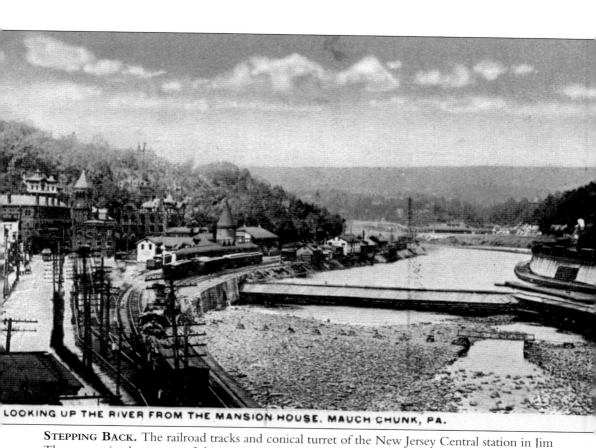

LOOKING UP THE RIVER FROM THE MANSION HOUSE. MAUCH CHUNK, PA.

STEPPING BACK. The railroad tracks and conical turret of the New Jersey Central station in Jim Thorpe are in the center of this card, and the Lehigh Canal hugs the base of Bear Mountain (right). The Lehigh River dam appears in front, while the Navigation Building and Asa Packer's mansion can be seen on the mountainside. For over a century, Josiah White, Erskine Hazard, and Asa Packer's names have been prominent in Mauch Chunk. Their reputations as the creators of the Lehigh Canal, the Switchback Railroad, and the Lehigh Valley Railroad, respectively, endowed them with an elevated status in Carbon County history, proving that true greatness transcends time. "The heights by great men reached and kept, were not attained by sudden flight, but they while their companions slept, were toiling upward in the night." (Henry Wadsworth Longfellow.) (Postcard courtesy of Juliana Rhodes.)

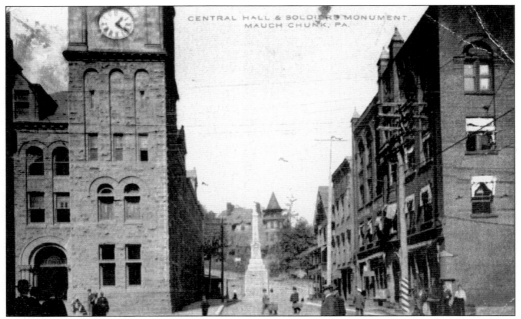

THE INTERSECTION OF BROADWAY AND SUSQUEHANNA STREETS, C. 1907. This card shows the Carbon County Courthouse (left) and Hotel Row, which includes the landmark Hotel Switzerland, still in operation. Carbon County Soldier's Monument is in front of Wentz Mansion, which was built on the former site of the Federalist home of Josiah White, known as Whitehall. After Whitehall was moved across the Lehigh River, Judge Leisenring built Parkhurst there. Parkhurst also preceded Wentz Mansion. (Postcard courtesy of Fred Bartelt.)

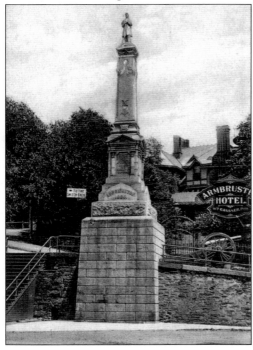

THE SOLDIER'S MONUMENT. Shown here is the Carbon County Soldier's Monument, erected in 1886 by the Chapman Post. The post was named for Maj. Lansford Chapman of Mauch Chunk, who died in battle at Chancellorsville. "At Antietam, the regiment was subjected to severe fighting; Captain Chapman was struck by a fragment of shell and sustained considerable injury. In January, 1863, he was promoted to the rank of Major and died in Chancellorsville." (Postcard courtesy of Glenn Finsel.)

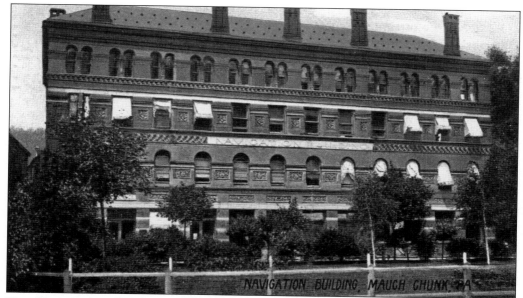

THE NAVIGATION BUILDING. This card shows the Lehigh Coal and Navigation Building on Susquehanna Street, a magnificent masonry building reminiscent of French architecture. In 1908, Lehigh Coal and Navigation employed 5,482 employees inside and outside its mines. "The miners are almost all of foreign birth, the Irish being the most numerous, next the Welsh, then the Germans, and lastly the English and Scotch. Among the miners there are some Pennsylvania Germans." (Postcard courtesy of Clarence Getz.)

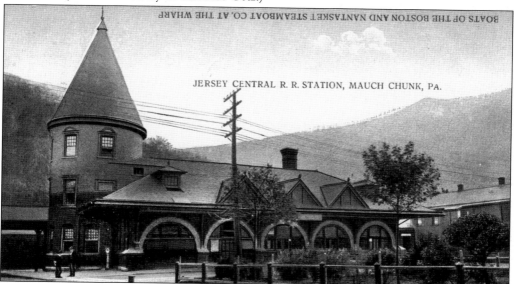

NEW JERSEY CENTRAL RAILROAD STATION. This card shows the conical turret that crowns this historic train station in Jim Thorpe. Built in 1868, the station was designed by Wilson Brothers Architects of Philadelphia, who also designed the American Philosophical Society Hall, Philadelphia Dental College Hospital, Drexel University, Coney Island Railroad Station, and more. The railroad station is now the Jim Thorpe Visitors' Center and is on the National Register of Historic Places. (Postcard courtesy of Fred Bartelt.)

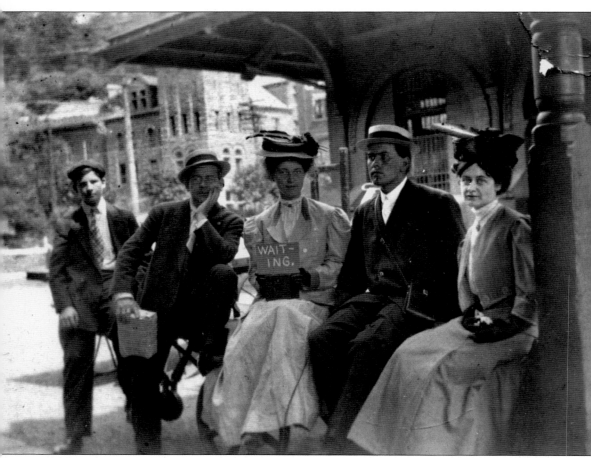

THE NEW JERSEY CENTRAL STATION. Here we see passengers waiting for their train. In 1900, Mauch Chunk was serviced by two railroads, the New Jersey Central Railroad and the Lehigh Valley Railroad. The Lehigh Valley Railroad station was across the Lehigh River. The Lehigh Valley Railroad's Black Diamond steam train reached cult status at the turn of the century. Filmed by Thomas Edison, two rare short films of the Lehigh Valley "flyer" were shot in 1896 and 1900. Both are available for viewing through the Library of Congress's Early Motion Pictures Collection. Although short in duration, these clips portray the power and beauty of this enigmatic steam train, eerie and exquisite. The first film shows the "Black Diamond emerging from a wood, approaching the camera under full steam. A section gang in the foreground, engaged in repairing track, wave their hats to the engineer, who is leaning out of the window." (Postcard courtesy of Robert Gelatko.)

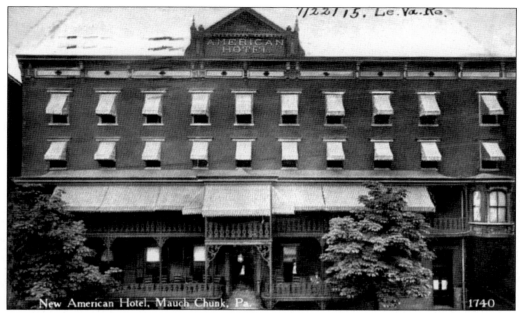

THE NEW AMERICAN HOTEL, C. 1900. "The intelligence that Fort Sumter had been fired upon spread through the county like a flame of fire. Lincoln issued a call for seventy five thousand volunteers. The people threw aside their ordinary vocations [and] thronged the streets, while the towering mountains re-echoed the strains of martial music; Mauch Chunk looked like a military encampment. After parading the streets, [the troops] drew up before the American Hotel [now the Inn at Jim Thorpe], where they were presented with a handsome flag made by the patriotic women of Mauch Chunk. The address of the presentation was made from the balcony by Charles Albright." (Postcard courtesy of Clarence Getz.)

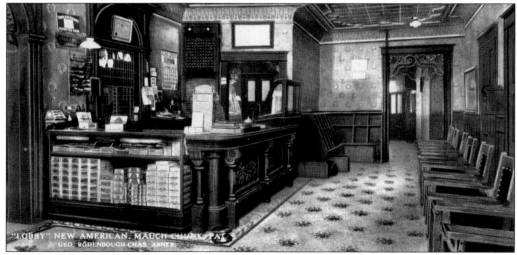

THE HOTEL LOBBY. The American Hotel (now the Inn at Jim Thorpe) is an exquisite structure, located on Broadway in the historic district of Jim Thorpe and listed on the National Register of Historic Places. Its classic New Orleans–style architecture, replete with antique wrought-iron balconies, is reminiscent of the picturesque old French Quarter. It has been an icon in Jim Thorpe since before the Civil War. (Postcard courtesy of Fred Bartelt.)

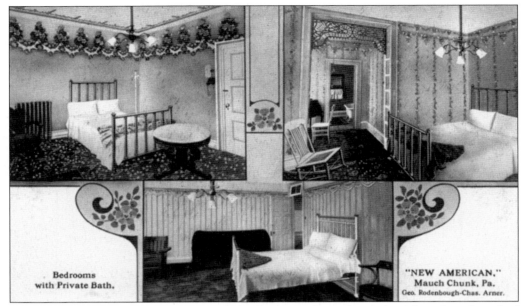

Bedrooms
with Private Bath.

"NEW AMERICAN,"
Mauch Chunk, Pa.
Geo. Rodenbough-Chas. Arner.

ROOM IN THE AMERICAN HOTEL, 1904. "It was eight, and a dark night, when I reached Mauch Chunk . . . so celebrated in the Union for its rich coalmines. On alighting, I was shown to the travelers' room, and on asking for the landlord; saw coming towards me a fine-looking young man, to whom I made known my wishes. . . . In a word, I was fixed in four minutes, and that most comfortably." (John James Audubon.) (Postcard courtesy of Juliana Rhodes.)

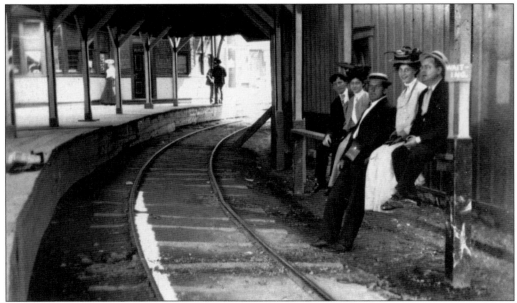

FINDING THE SWITCHBACK DEPOT. "The road follows first the west shore of the river and then ascends the hill, passing the beautiful residences of Hon. Asa Packer and Judge Leisenring . . . on terraces against the steep hill." (*Manufacturer & Builder*.) Victorian excursionists pose inside the Switchback depot in 1903, providing a rare glimpse of the depot's interior. (Postcard courtesy of Robert Gelatko.)

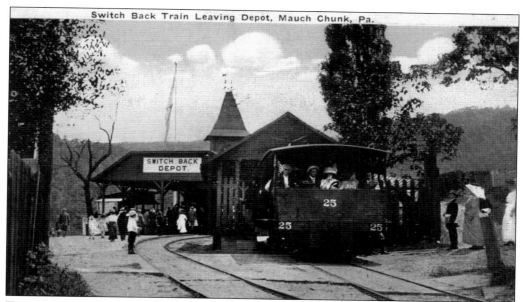

THE SWITCHBACK TRAIN DEPOT. The Switchback ran every day from May through November. "[Mount Pisgah] looks formidable enough . . . not less than 2,322 feet in length. There are two tracks, and upon each runs a safety car. . . . In all the years that this enterprise has been in operation, not a single passenger has met with an accident going up this mountain." (Postcard courtesy of Fred Bartelt.)

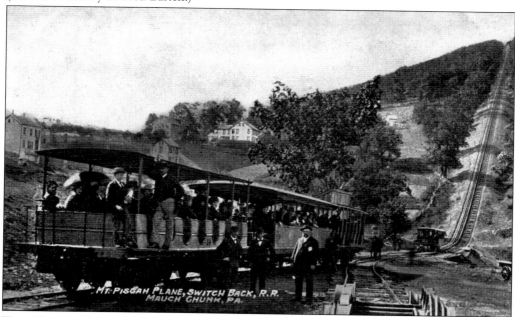

THE MOUNT PISGAH PLANE, 1905. This card shows how, upon leaving the depot, the car descends by gravity to the Mount Pisgah Plane. "At the foot of [the] plane . . . the mechanism of the cars and cables; at the top the application of power which lifts the cars with their human loads to the glorious heights where they begin their swift and fascinating journey along the wooded mountaintop towards the scene of Ginter's discovery." (Postcard courtesy of Fred Bartelt.)

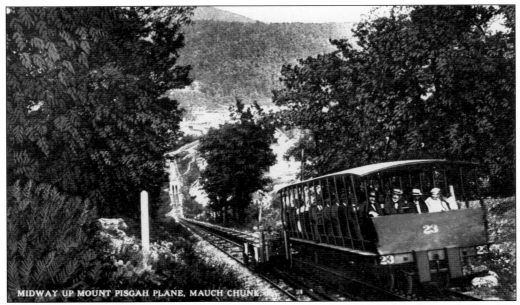

MIDWAY UP MOUNT PISGAH, 1905. "As an incline appears much steeper than it really is, the effect when riding in one of the closed cars, with a door behind, is very peculiar; it looks as if the car was set on end, with the door below, while many persons are afraid to look down through this opened door. But for those who courageously dare to look down, the sight is magnificent; the hills which at first were above us sink into insignificance." (*Manufacturer & Builder.*) (Postcard courtesy of Fred Bartelt.)

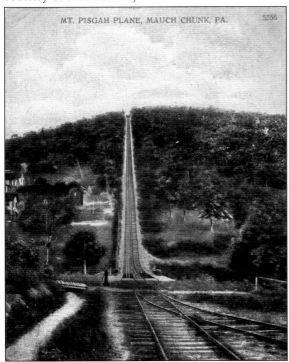

THE PINNACLE, *c.* 1900. Here we see the Switchback car at the pinnacle of Mount Pisgah. "We have now reached the summit of Mount Pisgah and attained an elevation of 1,370 feet above tide water. Everything seems to have been twisted and scrunched and hurled and piled together as if the elements of nature had been in rebellion when this part of the country was finished." (Postcard courtesy of Fred Bartelt.)

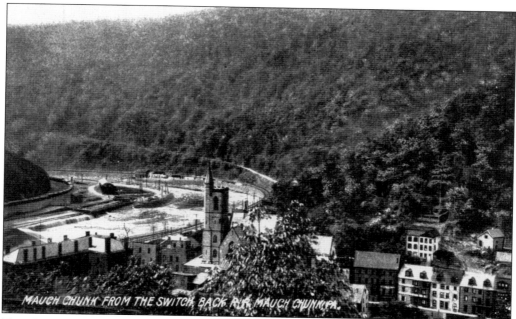

MAUCH CHUNK FROM THE SWITCH BACK R.R. MAUCH CHUNK PA.

THE VIEW FROM MOUNT PISGAH, 1904. This postcard conveys the wonderful depth and scenery from the top of Mount Pisgah as seen from the Switchback Railroad. As in the Bible's book of Deuteronomy, excursionists could "get . . . up into the top of Mt. Pisgah" and see "westward, northward, southward and eastward." (Postcard courtesy of Fred Bartelt.)

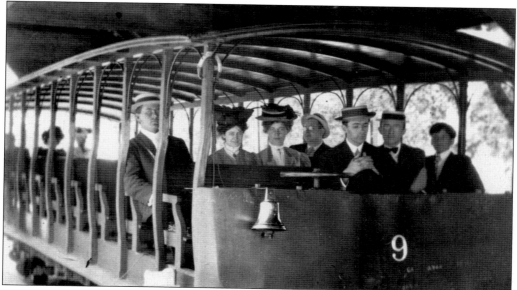

A SWITCHBACK CAR, C. 1905. While the car ahead of these travelers rests atop Mount Pisgah, these Victorian travelers contemplate what is up ahead. Promised a spectacular view, they will not be disappointed. The view from the pinnacle was sublime. The expanse of mountains appeared as if "the heavens opened wide." This real-photo postcard shows excursionists and a wide range of emotions. (Postcard courtesy of Fred Bartelt.)

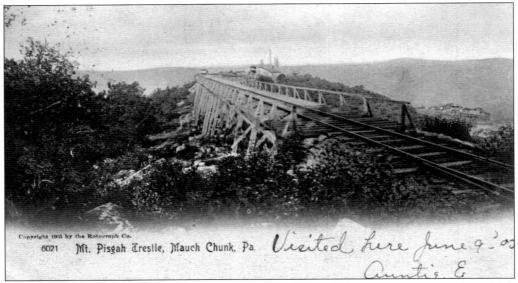

6021 Mt. Pisgah Trestle, Mauch Chunk, Pa. *Visited here June 9 '0?*
Auntie E

MOUNT PISGAH TRESTLE. In 1818, Josiah White embarked on a mission to improve the Lehigh River, a work abandoned by his predecessors seven times before. White and his partner, Erskine Hazard, were sometimes called "visionaries in extreme" because the undertaking seemed impossible. With faith in their own abilities, however, they completed both the Lehigh Canal and Gravity Railroad—achievements that were unsurpassed in their time. (Postcard courtesy of Fred Bartelt.)

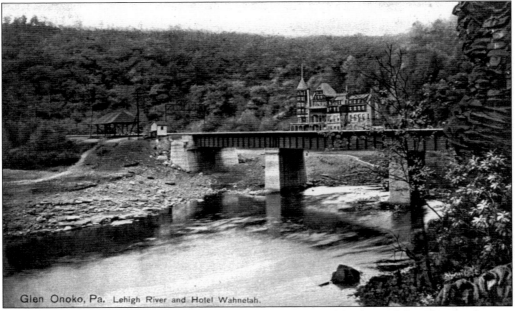

Glen Onoko, Pa. Lehigh River and Hotel Wahnetah.

THE HOTEL WAHNETAH. In 1870, the Lehigh Valley Railroad landscaped the Glen Onoko area and opened a depot, which became known as the playground of the Lehigh Valley. A dance pavilion, fountains, terraced gardens (with benches for lovers), and a picnic area enhanced the experience of travelers. The Hotel Wahnetah is seen in the background. (Postcard courtesy of Hilbert Haas.)

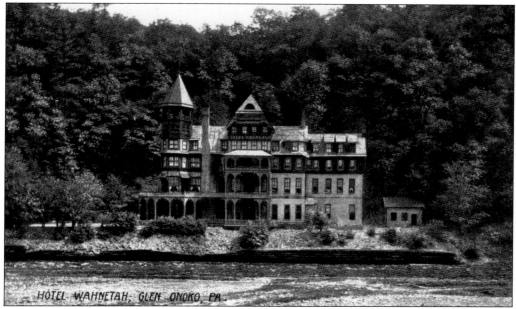

HOTEL WAHNETAH, GLEN ONOKO, PA.

THE HOTEL WAHNETAH. Photographs of Hotel Wahnetah are included in the Library of Congress's Gottscho-Schleisner Collection, 1896–1970, which features the images of renowned photographers Samuel Gottscho and William Schleisner. The two were commissioned by architects, writers, and members of the bohemian elite. It is interesting, yet not surprising, that Wahnetah was chosen as a subject. The mysterious structure, destroyed by fire, had a mystical quality present in even the poorest of photographs. (Postcard courtesy of Richard Funk.)

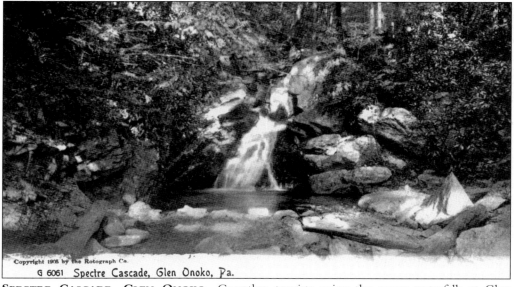

Copyright 1905 by the Rotograph Co.
G 6061 Spectre Cascade, Glen Onoko, Pa.

SPECTRE CASCADE, GLEN ONOKO. Countless tourists enjoy the many waterfalls at Glen Onoko. Fanciful names were given, such as Hidden Sweet Cascade, Moss Cascade, Lover's Bath, Pulpit Rocks, and Heart of the Glen. (Postcard courtesy of Richard Funk.)

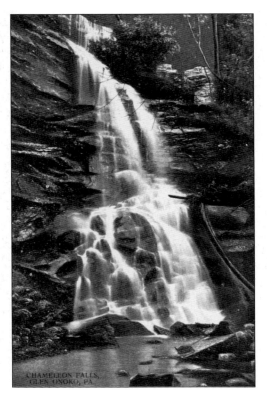

CHAMELEON FALLS, GLEN ONOKO, 1900.
The Lehigh Valley Railroad owned the land at the Glen Onoko Depot and worked very hard in the late 1800s to make it more accessible and safer. The Glen, an exquisite natural landmark, can be treacherous. The estimated height of Cave Falls is a steep 45 feet, and Onoko Falls "plunges downward in a most picturesque sheet seventy five feet." (Postcard courtesy of Richard Funk.)

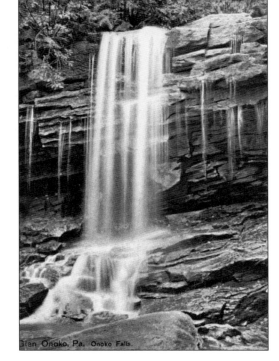

ONOKO FALLS, GLEN ONOKO, 1900.
These three views of the Glen Onoko Falls join Hotel Wahnetah as part of the definitive Gottscho-Schleisner Collection. Although these prestigious photographers' works were primarily of architecture and 20th-century American interiors, the magnificent presence of Glen Onoko was hard to resist. (Postcard courtesy of Richard Funk.)

64

CRYSTAL CASCADE, 1900. A haphazard array of ancient stones forms the basis for multiple cascades at Glen Onoko Falls. High above Glen Onoko, at the mountain's summit, the best view in Carbon County can be had at the amazing Hitcheltooth Cliffs, the holy grail of scenic overlooks. (Postcard courtesy of Richard Funk.)

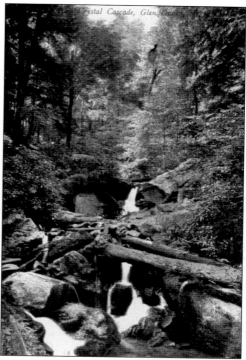

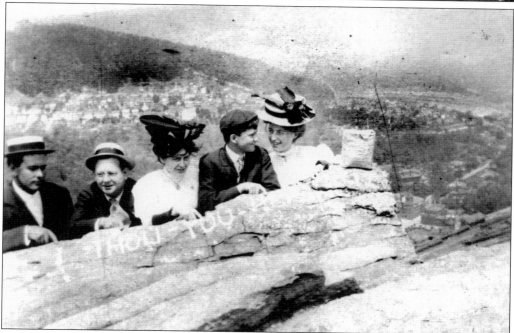

FLAGSTAFF PARK, 1899. "The lights of Flagstaff Park seem to mingle with the stars." (Brenckman.) Flagstaff Park, located on the top of South Mountain, has been a popular attraction since the mid-1800s. It is known for its spectacular view of Jim Thorpe and the Lehigh River valley. (Postcard courtesy of Robert Gelatko.)

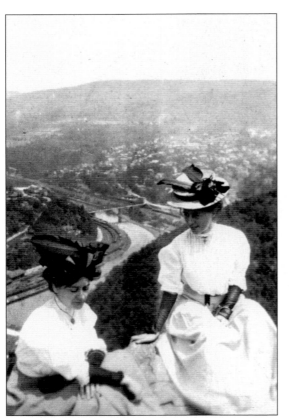

LADIES AT THE FLAGSTAFF. From the Flagstaff, "grand views can be obtained of a vast scope of mountain, valley and river, forest, farm and peaceful villages nestled among the hills. The eye reaches the Lehigh and the Delaware Water Gaps, Wind Gap . . . the Blue Mountains, and all the nameless, billowy ranges between. From Flagstaff, Mauch Chunk appears below as if laid out upon a map." (Mathews and Hungerford.) The American Indians indigenous to Carbon County were well aware of the views from the Blue Mountain with its proximity to the Warrior's Path "whether in the vernal green of summer, when the laurels add the luster of their man-tinted blossoms; in the autumn, when the mountains glow and glaze with color, or even in the depth of winter, clad in snow, to which the only contrast is afforded by the gray and leafless trees and the somber hue of the hemlocks." (Mathews and Hungerford.) (Postcard courtesy of Robert Gelatko.)

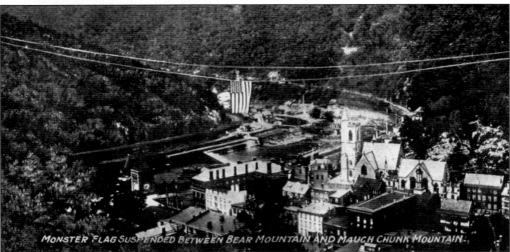

MONSTER FLAG SUSPENDED BETWEEN BEAR MOUNTAIN AND MAUCH CHUNK MOUNTAIN.

FROM THE FLAGSTAFF. The Lenni Lenape Indians may have seen their first white men from the top of South Mountain. The ancient Lenape poem *Walum Olum,* the only piece of Lenni Lenape literature in existence, tells the tale of that first glimpse in a primitive meter similar to *Beowulf:* "The great land and a wide land was the east land. / Great fighter was chief toward the North. / All were friends; all were united. . . . At this time whites came in the Eastern Sea. . . . From North and South, the whites came." (Postcard courtesy of Lee Mantz.)

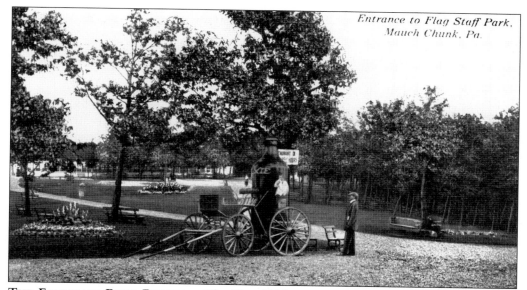

THE FLAGSTAFF PARK PAVILION. The Hare Krishnas appreciated a beautiful view. In 1987, they were interested in purchasing the Flagstaff, but plans for an elaborate palace and accommodations for over 42,000 fell through. (Postcard courtesy of Fred Bartelt.)

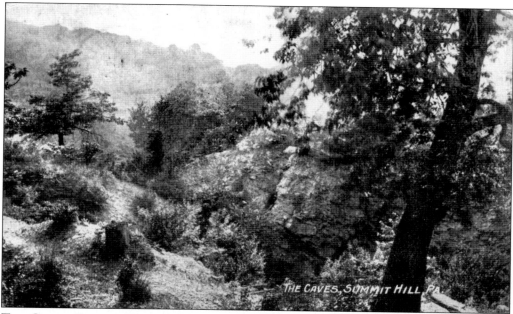

THE CAVES, SUMMIT HILL. Philip Ginder discovered anthracite coal on Sharp Mountain (now Summit Hill) in 1791. Primitive and uninhabited like the caves, Sharp Mountain resembled, to use Darwin's words, a place "where human foot hath never or rarely been." Anthracite was the discovery of the century, yet at first "people would neither purchase it or, when they did, would afterwards complain of being imposed upon, nor would they take it as a gift." Later its "own good qualities along with reasonable price, rapidly increased its demand." (Postcard courtesy of Lee Mantz.)

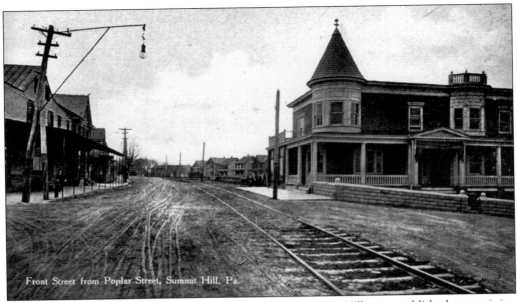

FRONT STREET FROM POPLAR STREET, C. 1900. Summit Hill was established as a mining camp by Lehigh Coal and Navigation in 1818. Mathews and Hungerford stated that Summit Hill was "with the exception of Mauch Chunk, the leading center of population in the region settled and developed by the Lehigh Coal and Navigation Company." (Postcard courtesy of Lee Mantz.)

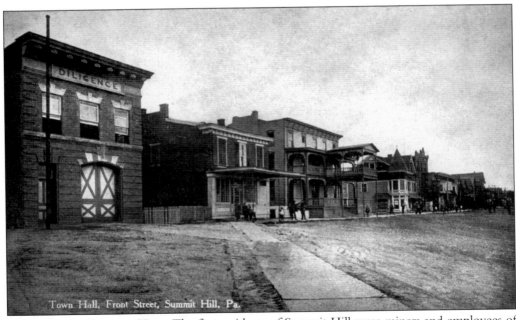

TOWN HALL, SUMMIT HILL. The first residents of Summit Hill were miners and employees of the Lehigh Coal and Navigation Company. In 1821, the mining camp began to resemble a civilized town. The first resident of Summit Hill was James Broderick. This early view of Summit Hill shows storefronts of yesteryear and the newly built town hall, home of the Diligence Fire Company, which replaced the armory in 1908. (Postcard courtesy of Lee Mantz.)

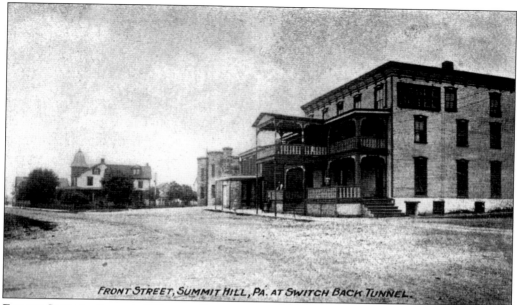

FRONT STREET, SUMMIT HILL, PA. AT SWITCH BACK TUNNEL.

FRONT STREET. Summit Hill, as well most of Carbon County, was home to many immigrants attracted to the plentiful work in the mines. "The Welsh [miners] have been accused of keeping together. They are . . . lovers of liberty, stubborn and enduring, not fickle. The Welshman is an experienced miner in his own rugged country. The Welshman is the miner, who blasts and takes down the coal." (Gibbons.) (Postcard courtesy of Lee Mantz.)

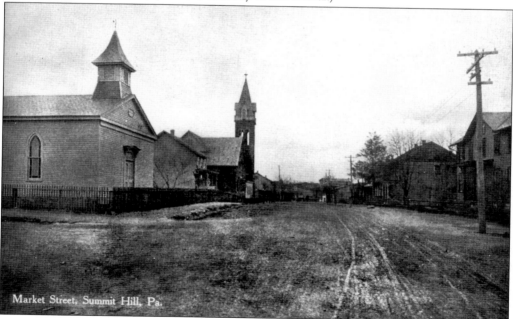

Market Street, Summit Hill, Pa.

MARKET STREET. The census of 1880 recorded the population of Summit Hill as 1,763, almost all coal miners and their families. "Besides the more fearful sufferings to which the miner is liable, it is not uncommon to see him working in water, perhaps up to his knees and at the same time water may be dropping upon him from above." (Gibbons.) (Postcard courtesy of Lee Mantz.)

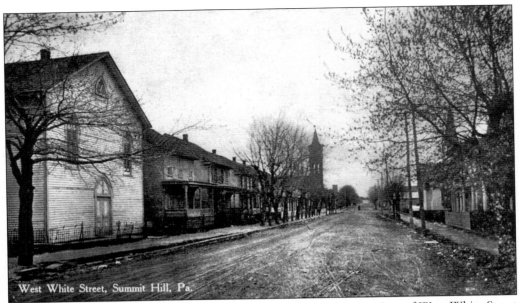

West White Street, Summit Hill, Pa.

WEST WHITE STREET, SUMMIT HILL, C. 1907. This card shows a view of West White Street in Summit Hill. Records reveal that in 1826, there was one house in the town. Summit Hill began to resemble a town after Lehigh Coal and Navigation began erecting houses for its employees shortly thereafter. The company's regulations for tenants stated that employees "are to pay their rent quarterly. They are to keep an orderly House and take reasonably good care of it and no Tenant is allowed to take into his house any other family than his own." (Postcard courtesy of Lee Mantz.)

THE PARADE ROUTE. Summit Hill is shown *c.* 1903 in parade regalia. "As to the number of miners who own their houses, I have heard various estimates." (Gibbons.) Many miners rented their homes from Lehigh Coal and Navigation Company, and the rules established for tenants stated in 1832, "All Hands to avoid Drunkenness, Quarreling and Fighting." (Postcard courtesy of Lee Mantz.)

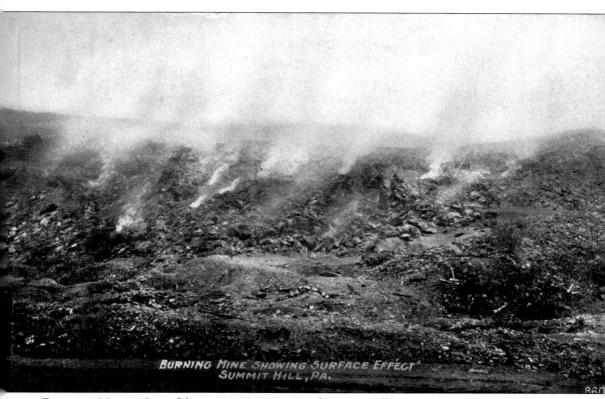

BURNING MINE SHOWING SURFACE EFFECT
SUMMIT HILL, PA.

BURNING MINES. One of the most curious aspects of Summit Hill history is an "attraction" called the Burning Mines, shown on this postcard from 1910. Underground fires are common in coal-mining areas, and many are never fully extinguished. According to the Department of Environmental Protection, in 1998, approximately 1,300 acres across the state of Pennsylvania had underground fires burning. In 1877, travelers to Summit Hill had some interesting comments about this unusual tourist attraction, the origin of which was never found. "Here one of the first things we were shown was a burning mine, but it was a poor affair, recently kindled and on the verge of being extinguished. The only noticeable thing about it was the process of putting out the fire by forcing carbonic acid gas into the mine, and that we did not see. There is another mine at Summit Hill, which has been burning for thirty years, and is likely to burn for thirty more: that, now, is something to brag of." (*Highways and Byways.*) (Postcard courtesy of Lee Mantz.)

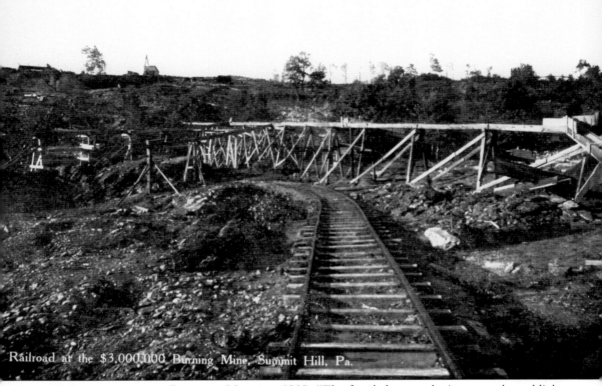

Railroad at the $3,000,000 Burning Mine, Summit Hill, Pa.

A SCENE NEAR THE BURNING MINE, C. 1905. "The fires below awoke in anger, the red light blazed, and all the cavern was filled with a great glare and heat." (J. R. R. Tolkien.) Regarding the extinction of the underground mine fires in Summit Hill, most felt that the most obvious way to extinguish this slow-burning blaze was water. Unbelievably, water could not put out the fire. "The intensity of the underground fire was so extreme it was volcanic and when cooled down it would disintegrate into tiny fragments." Underground mine fires are rampant in Pennsylvania due to the overabundance of mining; the Federal Office of Surface Mining defines the problem as "continuous smoke, haze, heat, or venting of hazardous gases from underground mine coal combustion posing a danger to public health, safety and general welfare." (Postcard courtesy of Lee Mantz.)

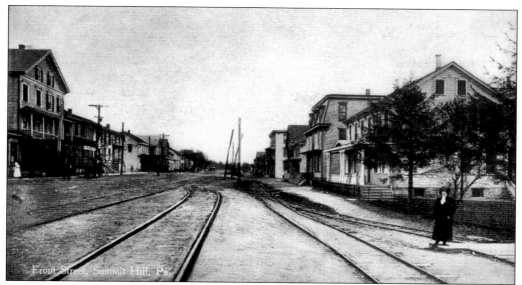

BURNING MINES, 1859. The Burning Mines brought tourists to Summit Hill for this unusual attraction. "The progress of the fire has been in a westerly direction from the town, during the half century of its existence it has traversed approximately a mile, consuming millions of tons of coal in its slow but desolating march. Repeated efforts have been made to extinguish this devouring underground conflagration." (Postcard courtesy of Lee Mantz.)

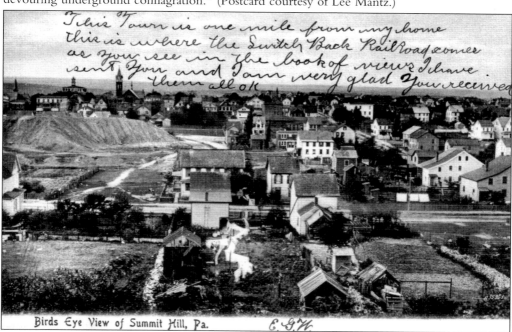

A BIRD'S-EYE VIEW. A note on this postcard reads, "This Town is one mile from my home, this is where the Switch Back Railroad comes. GBW." Gibbons remarks, "Coal mines were cool during the summer months and very warm in winter, the mood in the mines, despite the danger, was usually easy. When lulls in work were caused by some external cause, it was common for the men to . . . liven things up with stories." (Postcard courtesy of Lee Mantz.)

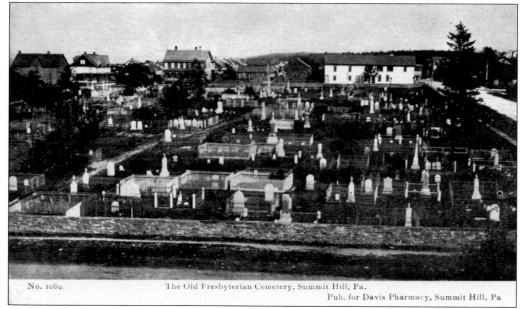

No. 1089. The Old Presbyterian Cemetery, Summit Hill, Pa.
Pub. for Davis Pharmacy, Summit Hill, Pa

THE OLD PRESBYTERIAN CEMETERY. This Summit Hill cemetery no longer exists above ground. Over 30 years ago, it fell into disrepair, was bulldozed over, and is now a park. This cemetery looks quite well on the postcard, but in later years most of the tombstones were damaged beyond repair. There are at least 12 Civil War soldiers and one Revolutionary War soldier buried here. (Postcard courtesy of Lee Mantz.)

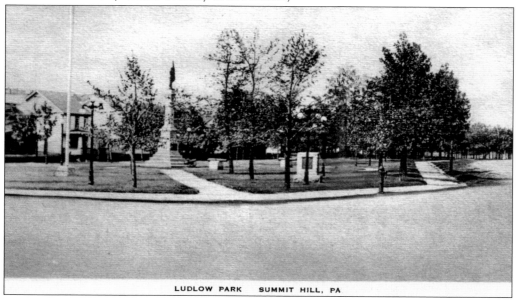

LUDLOW PARK SUMMIT HILL, PA

LUDLOW PARK. Located east of Sharp Mountain Quarry, Ludlow Park was granted a historic marker in 1991, commemorating the discovery of anthracite coal. "While hunting, Ginter discovered anthracite on Sharp Mountain here in 1791. He showed it to Col. Jacob Weiss. . . . In 1792 Weiss and others formed the Lehigh Coal Mine Co., the first Anthracite company and a forerunner of Lehigh Coal & Navigation." (Postcard courtesy of Lee Mantz.)

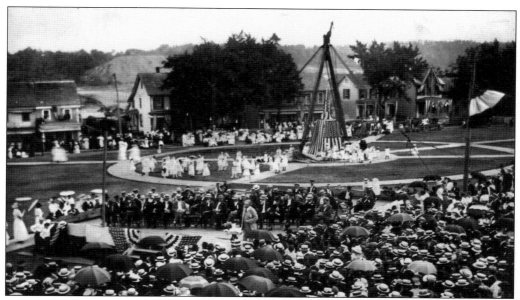

CIVIL WAR DEDICATION. This stunning photograph postcard from 1914 shows the dedication of the Summit Hill Civil War Monument. Taken from the Eagle Hotel just before the soldier was uncovered, this is a very beautiful picture of a momentous event. Here we see all of Summit Hill, dressed in their finest, from schoolchildren (left center) to the men and women, some with umbrellas, in the foreground. Lehigh Coal and Navigation leased the land to the Summit Hill Town Council in 1913 for a park. (Postcard courtesy of Lee Mantz.)

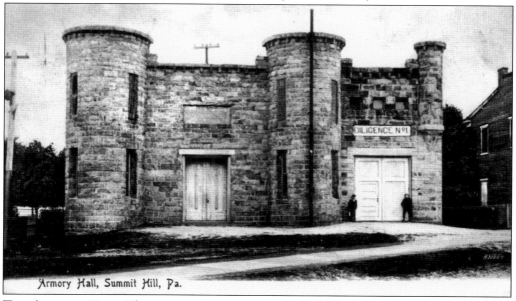

Armory Hall, Summit Hill, Pa.

THE ARMORY HALL. The armory was an icon in Summit Hill. Built in 1854, it resembled the French Bastille, with walls and towers of stone and narrow medieval windows. The gathering place of the Carbon Guards, most of whom were killed in the Civil War, it was destroyed by fire in 1908. Stones from the building were reused in the foundation of Citizen's Bank, Lansford. (Postcard courtesy of Lee Mantz.)

Summit Hill School. This photograph shows the Lincoln School, Summit Hill, *c.* 1900. "The education of miners' sons is often much neglected. The law does not permit them to enter the public schools before the age of six; and although the Ventilation Act prevents children from working within the mines under twelve no prohibition exists regarding the breaker or cracker above the mine. A friend says that as soon as the boy earns fifty cents at the mine, his sole ambition is to earn seventy-five, and then to become a driver. From driving one mule his desire is to drive a team, then to become a laborer, and then a full miner. To be a boss or superintendent is a distant object of ambition like being President. For the benefit of the boys in the mines the Catholic Church organized night schools, open during the six colder months of the year. Though principally organized by the Catholic Church, none are refused on account of their belief. But after working all day, the boy cannot bring so much animation to the night school as if he were not fatigued. The girls have better opportunities, but they are often put out to domestic service at twelve or fourteen." (Postcard courtesy of Lee Mantz.)

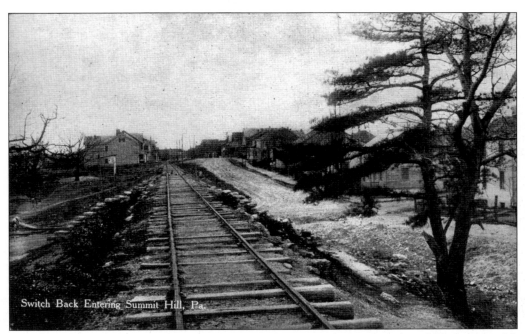

Switch Back Entering Summit Hill, Pa.

THE SWITCHBACK, ENTERING SUMMIT HILL. As a youth, Josiah White "filled time with experiments and inventions." In 1827, White conceived of a gravity railroad to move coal from Summit Hill, and four months later, it was a reality. Renamed the Switchback Railroad, this thrilling ride became available for excursionists and was deemed an "eighteen mile thrill ride to the most picturesque degree." (Postcard courtesy of Lee Mantz.)

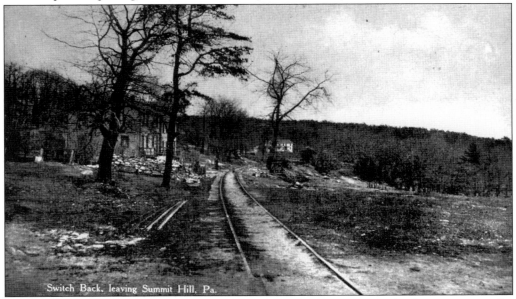

Switch Back, leaving Summit Hill, Pa.

THE SWITCHBACK ALONG FRONT STREET. White's Switchback inspired the first American roller coaster, designed in 1884 by LaMarcus Adna Thompson for Coney Island. This postcard shows the track for the Switchback, entering Summit Hill by way of Front Street. The Switchback became a tourist attraction, second only to Niagara Falls in popularity. (Postcard courtesy of Lee Mantz.)

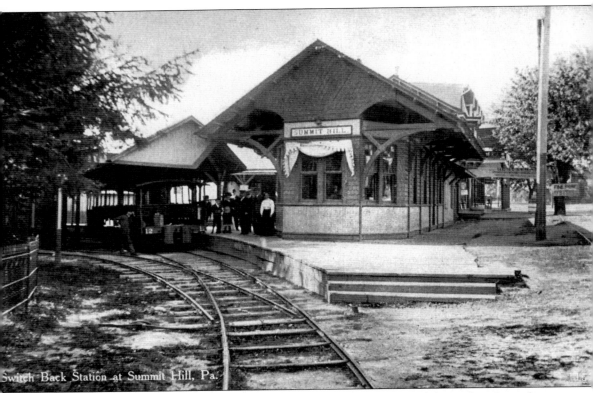

Switch Back Station at Summit Hill, Pa.

THE SWITCHBACK STATION, SUMMIT HILL. The Switchback, one of the most written about attractions in the history of books and periodicals, was a ride you remembered forever. "It was on a pleasant morning in early spring that I met the Artist and the Railroad-man at the depot of the North Pennsylvania Railroad, prepared to take the cars for what the Artist, who is addicted to punning, called 'the Switcherland of America.' Our object was partly business and partly pleasure. . . . Indeed, to be quite honest about it, we were all glad to have an excuse for a ten days' excursion in a region which promised so much outdoor entertainment. And the promise was kept." (*Highways and Byways of American Travel.*) (Postcard courtesy of Lee Mantz.)

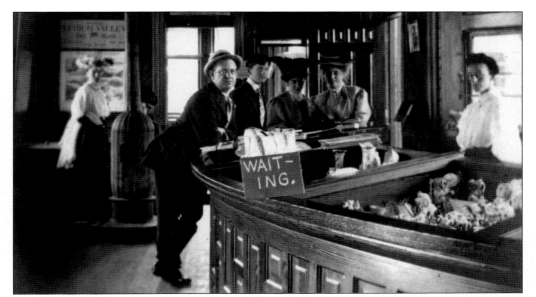

INSIDE THE SWITCHBACK STATION, SUMMIT HILL. This card shows a very rare view of the inside of Summit Hill's Switchback station *c.* 1900. The station was a comfortable place to wait for the train to come in. Note the coal stove near the back. Switchback and coal souvenirs were sold here. (Postcard courtesy of Robert Gelatko.)

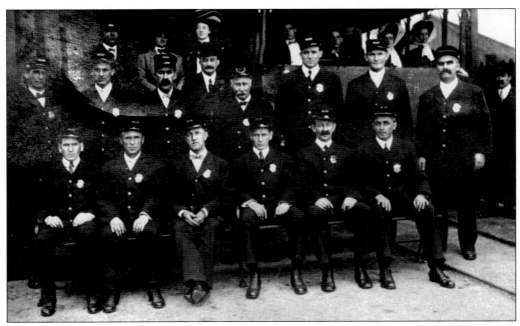

THE SWITCHBACK POLICE. This very rare photograph postcard shows the Switchback Police of Mauch Chunk. Included in the photograph are J. Barry, Tenny Clark, J. Sabach, Paul Acker, L. Rickenback, E. J. McGinley, J. Trout, Blocker Mench, Manus Heiney, Bill Conley, Joe Coll, F. Kanake, C. Blakeslee, Scotty Brower, J. M. Dolon. (Postcard courtesy of Lee Mantz.)

THE SWITCHBACK STATION, SUMMIT HILL, C. 1900. In this view, the Switchback station is shrouded in "a ghost of snow." (Robert Frost.) Poignant and lovely, a bit lonely, it waits for May, when it will be of use again. The length of the Switchback Railroad was 18 miles, when the upper and lower track were combined. The original gravity railroad cost approximately $3,050 per mile, or a total of approximately $38,776. (Postcard courtesy of Lee Mantz.)

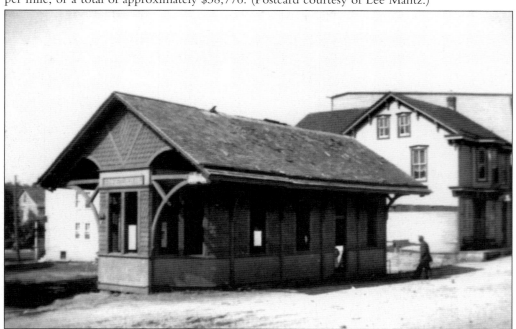

THE SWITCHBACK ON THE DOWNSIDE, C. 1930s. The Switchback station is shown being dismantled, almost down to the bone. Once throngs of passengers entered through its doors, exuberant from their thrill on the Switchback, but by 1936, Summit Hill residents questioned the safety of the old structure, which was in a serious state of disrepair. (Postcard courtesy of Lee Mantz.)

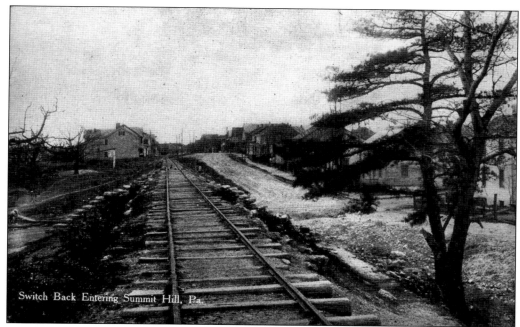

Switch Back Entering Summit Hill, Pa.

ALONG THE BANKS. In preparation for the gravity railroad that he and Josiah White would build, Erskine Hazard studied railroads in Europe. In his *Observations upon Rail-roads*, Hazard wrote that he was "decidedly of opinion, that in this country a rail-way of wood, sheathed with iron, would be preferable to any other, and could be kept constantly in order at the least expense." The Switchback Railroad was the second railroad built in the United States. (Postcard courtesy of Lee Mantz.)

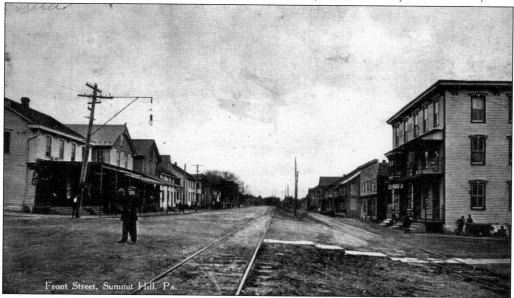

Front Street, Summit Hill, Pa.

SUMMIT HILL STREET, 1900. The ride to Mauch Chunk from Summit Hill via the Switchback has been described as "a pleasant, breezy, cool and clean run with no danger in it . . . returning late in the evening and whizzing down the nine miles between Summit Hill and Mauch Chunk in nineteen minutes." (Postcard courtesy of Lee Mantz.)

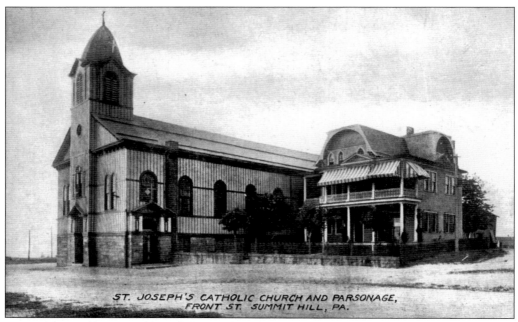

ST. JOSEPH'S CATHOLIC CHURCH AND PARSONAGE,
FRONT ST. SUMMIT HILL, PA.

ST. JOSEPH'S CHURCH, C. 1907. Alex Campbell and other Molly Maguires were buried in the cemetery of St. Joseph's in Summit Hill. Terrorists of the coal fields and murderers of mine bosses, the Mollies used violence to express their dissatisfaction with the conditions that miners were subjected to in the mines. (Courtesy of Lee Mantz.)

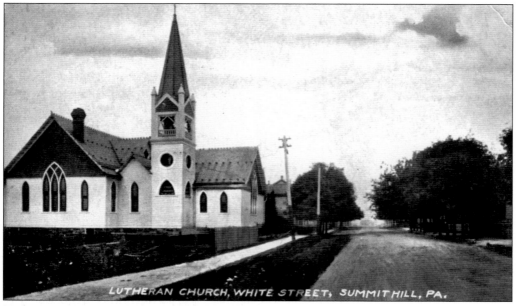

LUTHERAN CHURCH, WHITE STREET, SUMMIT HILL, PA.

THE LUTHERAN CHURCH, WHITE STREET. Although pay was meager and expenses were many, the miner's wife would always set aside an allotment for church tithing. "Miners wives generally hold the purse. As soon as he gets his pay . . . the miner hands his wages to his wife, who acts as treasurer with much discretion, making all the purchases of the house and transacting the business." (Gibbons.) (Postcard courtesy of Lee Mantz.)

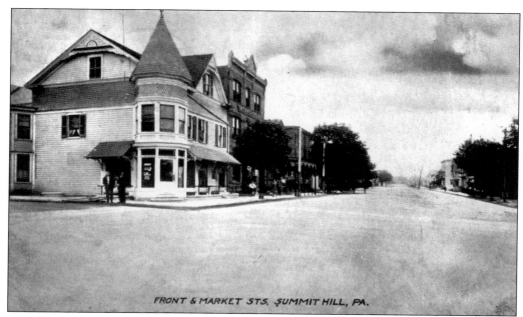

FRONT & MARKET STS. SUMMIT HILL, PA.

FRONT AND MARKET STREETS. "The chief hardship of a miner is the insecurity of his life. He is liable to accidents at any moment, either in blasting the coal, or from the falling of the roof in the passages and chambers of the mine, or from the explosion of fire-damp, carburetted hydrogen gas, an extremely explosive substance generated in the mine. By an awful accident which occurred in the Avondale mine, more than one hundred men were suffocated below." (Gibbons.) (Postcard courtesy of Lee Mantz.)

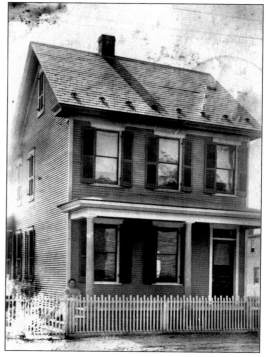

THE MINER'S PLIGHT. This Summit Hill home is shown *c.* 1910. "There has rarely been . . . a time when all the mines were worked, and there has scarcely been a moment when any one of them has worked to the full extent of the capacity of the labor employed. Yet the average price of coal to the consumer, during this period has been unreasonably high and occasionally exorbitant rates have been demanded." ("The Anthracite Problem," 1871.) (Postcard courtesy of Lee Mantz)

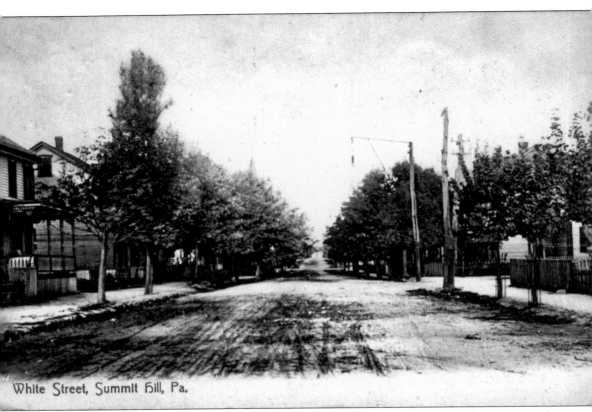

White Street, Summit Hill, Pa.

A MINER'S LAMENT. The anthracite coal industry created animosity between the miners and the wealthy mine owners. The poverty and inequality suffered by the immigrant miners manifested itself in the renegade group the Molly Maguires. Although written in Europe, the following passage from an 1844 article in the *Living Age* reveals the same anger and frustration that fed into the Molly Maguires, supported by many American miners: "And while you gaze [on the mansions of wealthy mine owners] the impression irresistibly comes upon you, that the monstrous wealth of a few, is the result of the monstrous suffering and degradation of the many." (Postcard courtesy of Lee Mantz.)

Three

THE GREAT PINE SWAMP

I left Philadelphia, at four of the morning, with no other accoutrements
than I knew to be absolutely necessary for the jaunt I intended to make.
These consisted of a wooden box, containing a small stock of linen, drawing paper,
my journal, colours and pencils, together with 25 pounds of shot.

—John James Audubon, *The Great Pine Swamp*

In 1829, John James Audubon arrived at the tiny logging settlement of Rockport to stalk and paint the native birds of the Great Pine Swamp (also known as the Great Pine Forest). For six weeks, he resided with Jediah Irish, an astute woodsman with a penchant for poetry, the perfect complement to Audubon's vast eccentricities and needs as an ornithological painter. Together, Audubon and Irish explored the dense and mysterious wilderness on both sides of the upper Lehigh River. Audubon's account of his experience is the basis of his treatise entitled *The Great Pine Swamp*. Here he recalls his time spent with Irish:

> The long walks and long talks we have had together I never can forget, or the many beautiful birds which we pursued, shot, and admired. And then, what pleasure I had in listening to him as he read his favorite Poems of Burns, while my pencil was occupied in smoothing and softening the drawing of the bird before me.

Audubon's impressions of Rockport provide a valuable account of lumbering operations in Carbon County. They provide a rare glimpse, like that of the most elusive of birds, into this place and time.

Rockport, Weatherly, and Laurytown are all located at the top of Broad Mountain and, although in the same county, seem far removed in geography and culture from each other. Located in the uppermost regions of the coal-mining district, Weatherly was an industrial site, home to the Lehigh Valley Railroad shops and the manufacturing site of locomotives, while Laurytown was the location of the county poorhouse, and Rockport was a lumbering town.

WELCOME TO WEATHERLY. North of Mauch Chunk is Weatherly. The town was settled in 1826 by Samuel Barber and John Romig, both of whom farmed and timbered. Besides these two settlers, the wilderness was uninhabited until 1840, when the Beaver Meadows Railroad was established. The Beaver Meadows Railroad transferred its shops to Weatherly eventually, which was beneficial to its economy. A 1910 history tells us that "its foundries and machine shops employ more than two hundred men, and the railroad repair shops about one-fourth of that number. Everything connected with the town is in a thriving and prosperous condition." (Postcard courtesy of Richard Funk.)

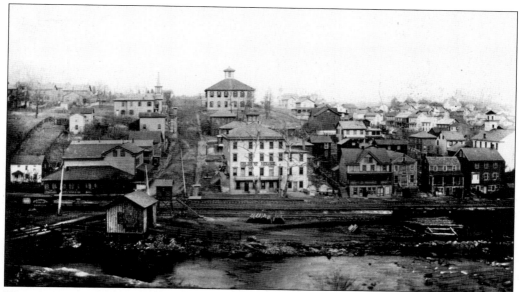

WEATHERLY, 1880. The Gilbert House and old Weatherly School figure prominently on this postcard. "[Weatherly] consisted of but a few small houses until the Beaver Meadow Railroad was completed. In order to overcome what was considered at that time a very heavy grade, they made this the stopping-point for the engines that took the coal . . . to Mauch Chunk." (Postcard courtesy of Richard Funk.)

THE RAILROAD SHOPS. Superb craftsmanship reigned in the Lehigh Valley Railroad shops in Weatherly. Said to build the finest locomotives in the state, the shops were under the management of supervisor Philip Hoffecker, who left the Beaver Meadows Railroad for the Lehigh Valley. In the Weatherly shops, Mr. Paul, a German-born artist, adorned the wood-burning trains with gold leaf and the high colors of his heritage. (Postcard courtesy of Richard Funk.)

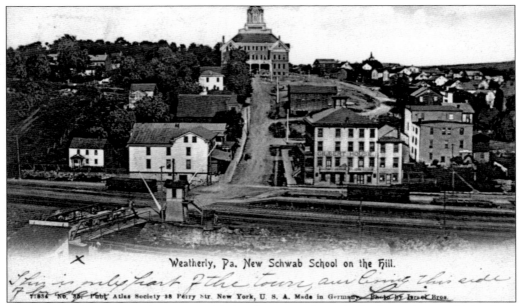

Weatherly, Pa. New Schwab School on the Hill.

This is only part of the town, and living this side

T1854 No. 76 Publ Atlas Society 38 Perry Str. New York, U. S. A. Made in Germany. Photo by Israel Bros.

THE NEW WEATHERLY SCHOOL, C. 1903. This view of Weatherly shows the new high school on the hill, built by steel magnate and millionaire Charles M. Schwab. Schwab's wife was raised in Weatherly and Schwab built the school for the town in appreciation of her fine childhood. Made of brick, this stunning building was appraised at over $70,000 after completion. (Postcard courtesy of Richard Funk.)

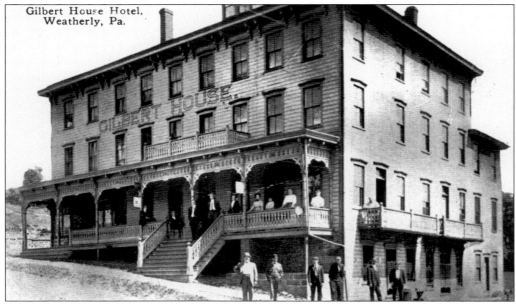

Gilbert House Hotel, Weatherly, Pa.

THE GILBERT HOUSE. This antique postcard shows a photograph of the site of "the first tavern in Weatherly," built by Benjamin Romig in 1831. After Romig's original tavern, another hotel was built on this site by William Tubbs, which preceded the eventual construction of the Gilbert House. This hotel was named after the landlord, Charles Gilbert, who served from 1843 to 1848. (Postcard courtesy of Richard Funk.)

THE WEATHERLY HOTEL. This card reads, "Weatherly Hotel corner Carbon and Second St. Received letter and postals much obliged. Any cases of dyspepsia at the fort. Clara. October 20th 1906." The Weatherly Hotel was established on the same site as the Packer House, a profitable business for many years, constructed by Aaron Grimes in 1856. (Postcard courtesy of Richard Funk.)

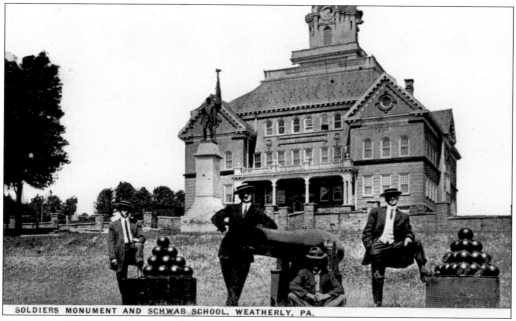

SOLDIERS MONUMENT AND SCHWAB SCHOOL, WEATHERLY, PA.

SOLDIERS MONUMENT AND SCHWAB SCHOOL, C. 1901. Eurena Schwab visited her hometown of Weatherly regularly. Back home, "she was simply a girl again . . . forgetting for the time the immense interests" of her husband, millionaire Charles Schwab. Eurena's husband made his money in steel and shared the wealth when he built the town of Weatherly a fine new school in honor of his wife. (Postcard courtesy of Richard Funk.)

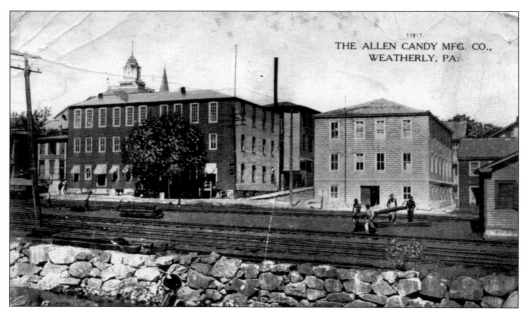

THE ALLEN CANDY MANUFACTURING COMPANY. After relocating from Allentown, Pennsylvania, in 1899, this became one of the most profitable businesses in Weatherly. Progressive and efficient, with a fine product, the company employed 50 full-time employees under the management of A. H. Horlacher. It was located parallel to Black Creek, where the first sawmill was built in Weatherly. (Postcard courtesy of Richard Funk.)

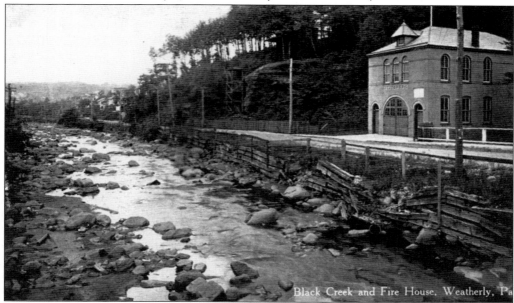

WEATHERLY'S FIRE COMPANY, 1893. The first fire chief was W. B. Lovatt. Firemen purchased their equipment by conducting fundraisers; one of the most profitable enterprises was a town fair. This early fire company became defunct in 1897, and fire protection service was temporarily interrupted. J. C. Sendel was one of the citizens who formed Citizens' Fire Company No. 1. (Postcard courtesy of Richard Funk.)

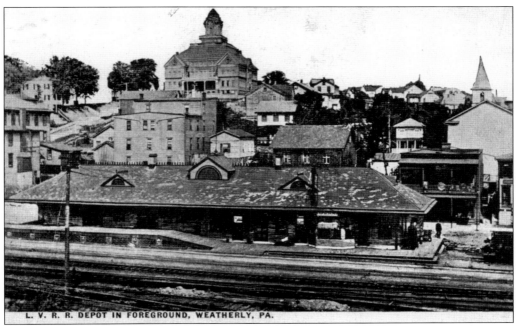

L. V. R. R. DEPOT IN FOREGROUND, WEATHERLY, PA.

THE LEHIGH VALLEY RAILROAD DEPOT, WEATHERLY, 1900. "Under the old regime of the Lehigh Valley, Weatherly was contented and prosperous. . . . The location of the place made it an advantageous point for general repair work. But Weatherly was too much a town of one industry and railroad towns are notoriously unstable." Weatherly's economy collapsed after the Lehigh Valley Railroad shops closed, causing unemployment and low morale. The industriousness of Weatherly residents, however, caused the economy to rebound. (Postcard courtesy of Richard Funk.)

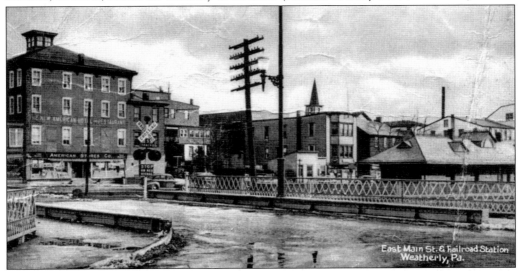

East Main St. & Railroad Station
Weatherly, Pa.

EAST MAIN. As one enters the town of Weatherly, located on the Lehigh Valley Railroad line, the railroad station is on the right. In 1910, the "territory of the town comprises four square miles and is bounded on the north, east, and southeast by Lehigh Township on the northwest by Lausanne Township and in the west and southwest by Packer Township." (Postcard courtesy of Richard Funk.)

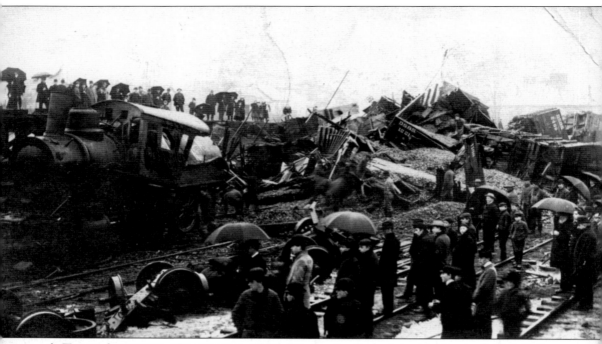

A Train Accident, Weatherly, 1907. "Under Asa Packer's leadership, the Lehigh Valley Railroad grew to become a colossal transportation system that stretched from New York City to Lake Erie at Buffalo, New York. In Weatherly alone, 100 trains were dispatched out of the depot every day." Train crashes were common in those days, but that did not diminish the horror. "In Weatherly, trains would often lose their brakes coming down the Weatherly hill and then derail at the curve along Hazle Creek." This amazing crash happened when a Lehigh Valley Railroad train's crew "had stopped at the top of the Weatherly Hill to check their timetable, and the train started rolling with no one aboard. The train sailed down the hill and derailed at the first turn coming into town, but it stayed on course with its wheels banging on the wooden ties until it hit the road crossing in the middle of town and re-railed itself, averting a disastrous wreck in Weatherly. The empty train finally crashed at the curve below town." (Postcard courtesy of Richard Funk.)

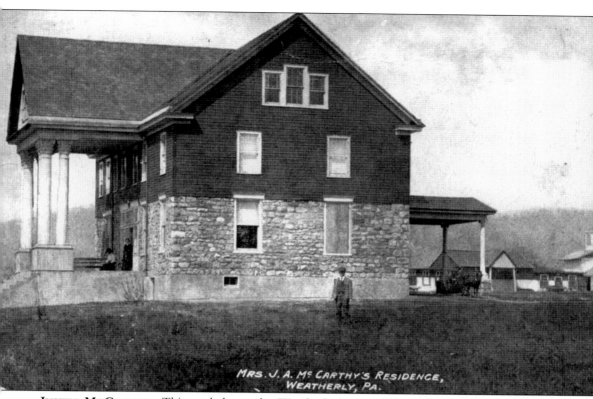

MRS. J. A. McCARTHY'S RESIDENCE,
WEATHERLY, PA.

JUSTIN McCARTHY. This card shows the Weatherly home of Pennsylvania folk artist Justin McCarthy. Built by McCarthy's father, a wealthy newspaper executive, the home was said to have a small theater on the third floor. Justin McCarthy was the oldest child of Floretta and John L. McCarthy. Justin had one brother, who died of pneumonia in 1907. A year later, Justin's father died suspiciously. Relying on her training as a schoolteacher, Mrs. McCarthy went back to work and earned extra money growing and selling vegetables from her garden with her son. The young man on the postcard could be McCarthy, and the woman on the front porch could be his mother. The caption reads, "Mrs. J. A. McCarthy's Residence," indicating that the photograph was captioned after John McCarthy's death. Justin was 16 years of age when his father died. Justin's artistic talents were discovered by the late Pennsylvania artist Sterling Strausser in Stroudsburg, Pennsylvania, in the 1960s. Justin remained in the Strausser circle until his death in 1977. His works continue to escalate in value. (Postcard courtesy of Richard Funk.)

THE ALMSHOUSE, LAURYTOWN. In 1855, the Pennsylvania legislature passed an act to build a house of employment (also known as a poorhouse or almshouse) for Carbon County and "authorizing directors of the poor. This institution was established at Laurytown." Almshouses, no matter how idealistic and well meaning the staff and directors, and no matter how many high-minded and generous benefactors there were, typically invited abuse and misery. (Postcard courtesy of Richard Funk.)

ALMSHOUSE, LAURYTOWN. To build the poorhouse at Laurytown, neighboring farms were purchased until the grounds totaled 315 acres at a cost of just over $5,000. The scourges of poorhouses in general were "overcrowding; poor food; insufficient clothing; neglect and abuse by the overworked and underpaid attendants." (*The Indoor Pauper*, by Octave Thanet.) Carbon County's facility seemed to be an example of none of the above. (Postcard courtesy of Richard Funk.)

OUTDOORS, LAURYTOWN. The first steward and matron of Laurytown Poorhouse were Jesse K. Pryor and his wife, who resided at the almshouse. By the summer of 1857, there were 54 inmates, and by 1861, there were 99. In 1862, "a number of poor districts in Luzerne County united with Carbon. Weatherly, Beaver Meadows, Summit Hill and Lansford with township of Lehigh." (Brenckman.) (Postcard courtesy of Richard Funk.)

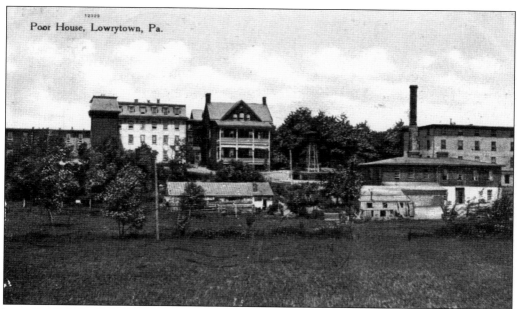

Poor House, Lowrytown, Pa.

THE POORHOUSE. Horror stories of poorhouses abound throughout history, as recounted in this tale from Europe: "To keep his patients quiet he used . . . straightforward arguments of force. His wife was matron. She was accustomed to 'mop' the women." (Thanet.) "Subject to stringent inspections, the Almshouse of Carbon County was a home of high standards, and little or no reported abuse." (Postcard courtesy of Richard Funk.)

b. by ED. MILLER, Weatherly. .The Main Street, Rockport.

MAIN STREET, ROCKPORT, C. 1900. By 1900, Rockport's lumbering days were long behind it. Rockport had been a village of sawmills and tenements, a haven for loggers and men of opportunity. Most of the land was owned by the Lehigh Coal and Navigation Company. Lumber, rafted down the Lehigh River to Mauch Chunk, was used for canal boats. Lumbermen returning home would walk the "Indian Path," which led north from Gnadenhutten along the river. The night of Audubon's arrival in Rockport, darkness came early and a storm had commenced, and his first impressions were imbued with the sound of rushing water in the darkness. "We winded round many a mountain, and at last crossed the highest. The weather had become tremendous, and we were thoroughly drenched, the boy was obliged to continue his driving. Having already traveled about fifteen miles or so, we left the turnpike and struck up a narrow and bad road, that seemed merely cut out to enable the people of the [Great] Swamp to receive the necessary supplies from the village which I had left." (Postcard courtesy of Richard Funk.)

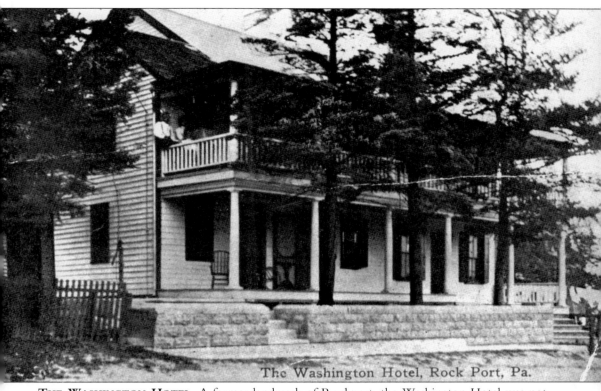

The Washington Hotel, Rock Port, Pa.

THE WASHINGTON HOTEL. A former landmark of Rockport, the Washington Hotel was not yet in existence the night Audubon arrived in Rockport, but if it had been, its lamplight would have warmed him on that starless night. Approaching Rockport, Audubon wrote, "We rattled down a steep declivity. The ground was so overgrown by laurels and tall pines of different kinds, that the whole presented only a mass of darkness." The black of night yielded to the hospitality found in the remote cabin of Jediah Irish, recommended to Audubon in Mauch Chunk for lodging. Audubon's imagery of the loggers' environs in Carbon County is one of few accounts in existence. "At length we got to the house," he wrote, "the door of which was already opened, the sight of strangers being nothing uncommon in our woods, even in the most remote parts. And on expressing a wish that I should be permitted to remain in the house for some weeks, I was gratified by receiving the sanction of the good woman to my proposal." (Postcard courtesy of Richard Funk.)

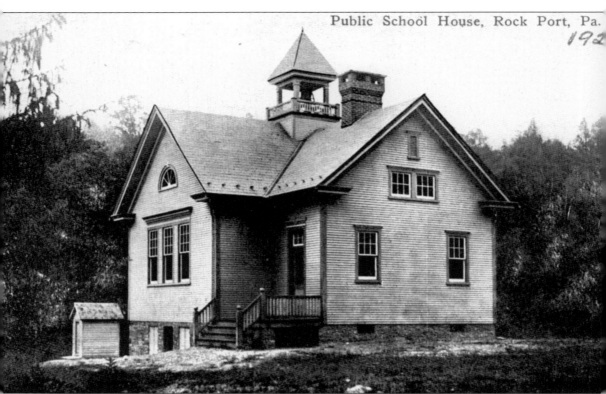

THE PUBLIC SCHOOLHOUSE, ROCKPORT. This schoolhouse, a quaint and wonderfully gabled clapboard structure with a cupola, is over a century old. Although Rockport was known for quality stone, the school is a testament to its fine lumber. Audubon's visit to Rockport occurred before its school was organized in 1875. There were children in lumber camps, but logging took precedence. Audubon observed that "in such an undertaking, the cutting of the trees is not all. They have afterwards to be hauled to the edge of the mountains bordering the river, launched into the stream, and led to the mills over many shallows and difficult places. To see them tumbling from such a height, touching here and there the rough angle of a projecting rock . . . at last falling with awful crash into the river, forms a sight interesting in the highest degree. When freshets take place, then is the time for forwarding the logs to the different mills. Irish, who is generally the leader, proceeds to the upper leap with his men. They all take to the water, be it summer or winter, like so many Newfoundland spaniels." (Postcard courtesy of Richard Funk.)

A COTTAGE IN ROCKPORT. On his first day in Rockport, Audubon wrote, "The storm had rolled away . . . displaying all its richness and beauty. My ears were greeted by the notes . . . of the Wood Thrush and other songsters. Before I had gone many steps. . . . I picked from among the leaves a lovely Sylvia, long sought for. I needed no more. . . . I was soon convinced that the Great Pine Swamp harboured many other objects as valuable to me." (Postcard courtesy of Richard Funk.)

A HOME NEAR ROCKPORT, 1910. The great Audubon was born in Louisiana in 1780. "His earliest recollections are associated with lying among the flowers of the fertile land in which he was born, sheltered by the orange trees, and watching the movements of the mocking bird, the king of song. He has remarked that his earliest impressions of nature were exceedingly vivid; and the beauties of natural scenery stirred a 'frenzy' in his blood." (Postcard courtesy of Richard Funk.)

On Line of L.V.R.R. Lehigh River Near Penn Haven Jct.

SCENIC PENN HAVEN, BROAD MOUNTAIN. Audubon left the Great Pine Swamp six weeks after his arrival. "Left to my thoughts, I felt amazed that such a place as the Great Pine Forest should be so little known. . . . How much is it to be regretted, thought I, that the many young gentlemen who are . . . so much at a loss how to employ their leisure days, should not visit these wild retreats, valuable as they are to the student of nature." Audubon left Rockport to follow the migratory birds south, never to return. Audubon recognized the beauty of the Lehigh River's unique geography at places like Oxbow Bend and Upper Falls. (Postcard courtesy of Cynthia Finsel-Sweitzer.)

Four

SHADES OF DEATH

Wyoming Valley was an isolated community in the country of a savage enemy. Two
ranges of mountains lay between the Susquehanna and the Delaware. The nearest
is the Pocono and on the south side of Wyoming it is a plateau rising a thousand
feet above the Valley, the greater part of which is still a dense forest filled with swamps.
The sufferings of those who fled through this region [during the Indian wars] baffles description.
Most of the fugitives turning from the desolated Valley plunged into the wilderness,
wandering in the marshes as chance or fear directed, without clothing, or food or guide,
seeking their way to the Delaware and thence to Connecticut. So great a number perished
from hunger and exhaustion, that these swamps have ever since been called the "Shades of Death."

Although the theories vary as to how portions of Hickory Run State Park and the vast primeval
wilderness of Kidder and Penn Forest Townships were called "Shades of Death," the reasons are
deeply rooted in American Indian history and bloodshed. Part of the Great Pine Swamp, this
dense acreage was called Shades of Death on Jefferson's map. Maj. Gen. John Sullivan and his
troops traveled through Kidder Township's Shades of Death on their way to the Six Nations
Indians in New York in 1779. A June 21 journal entry explains their take on the origin of
the name:

> This day we marched through the Great Swamp and Bear Swamp. The Great Swamp,
> which is eleven or twelve miles through, contains what is called in our maps the "shades of
> death," by reason of its darkness; both swamps contain trees of amazing height, viz.,
> hemlock, birch, pine, sugar maple, ash, locust, etc. The roads in some places are tolerable,
> but in other places exceedingly bad. . . . Three of our wagons and the carriages of two field
> pieces were broken down.

Another soldier reports passing one house in 36 miles and the "timber in the swamp, of
great size."

Ironically, Shades of Death would become known for a health resort that sought to heal those
with tuberculosis. A century after Sullivan's men trudged through the dark, swampy forest,
Sunnyrest was built on the fringes of Kidder Township in an area known for its pure mountain
air, which was thought to be curative.

THE SETTLERS. The first recorded settlement in Kidder Township was in 1842, and the first road blazed in 1843. Settlements like Hickory Run, Lehigh Tannery, Bridgeport, East Haven, Albrightsville, and Lake Harmony soon followed, along with schools and the inevitable post office. Lumbering and fires depleted the forests for a time, although they now resemble the ancient forests again. Oscar Dotter settled on 1,356 acres of land in the late 1800s. The family homestead remains on Route 940, near a family-owned tavern. "Os" married Stella Knorr, and together they worked the land and raised a family of three children. Most families in the Poconos at that time relied on hunting and fishing to put food on the table, but a prize buck like this was just as thrilling then as it for hunters in this era. Young Melvin Dotter, son of Oscar and Stella, poses here on the back of a trophy buck. Melvin and his two brothers, Charles and Raymond, along with their sister, Lona, were raised on their father's farm, one of the few farms in the Pocono Mountains. (Postcard courtesy of Glenn Finsel.)

OLD LOUNGE, SPLIT ROCK LODGE. Eighty percent of the settlers of Kidder and Penn Forest Townships were those seeking their fortunes as lumber barons, but the lumber did not last. John James Audubon expressed his regret about the disappearing trees in his treatise *The Great Pine Swamp.* "Timbering continued everyday and during calm nights, the greedy mills told the sad tale that in century the noble forest around should exist no more." (Postcard courtesy of Glenn Finsel.)

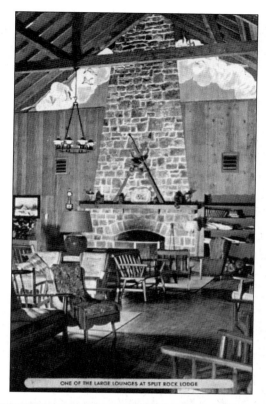

ONE OF THE LARGE LOUNGES AT SPLIT ROCK LODGE

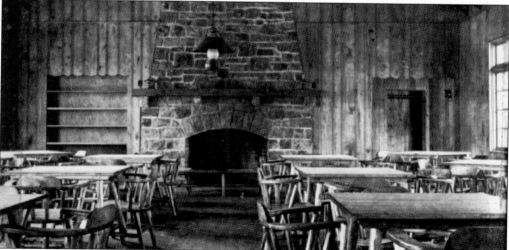

SPLIT ROCK LODGE, LAKE HARMONY, 1900. Split Rock Resort, once a hunting and fishing retreat, is now a four-season hotel. Located on a beautiful setting of 500 acres, the hotel overlooks Lake Harmony. Just over 170 years ago, the Lehigh Coal and Navigation Company purchased 45,000 acres in the Pocono Mountains to protect its headwater. When Robert V. White took over in 1938, he realized the natural potential of this beautiful place and within 10 years of its opening in 1941, it was one of the East's finest year-round sports resorts. Today it is still one of the most popular and historic sites in Lake Harmony. (Postcard courtesy of Glenn Finsel.)

A NATURAL WONDER. Primarily recreational now, Kidder and Penn Forest Townships are still known for their scenic forests, abundant with laurel, natural landmarks, and prime hunting and fishing. The fire of 1875 ravaged the Great Pine Forest (also called the Great Pine Swamp) and was the end of the lumbering business in Kidder and Penn Forest Townships. Starting on May 14 near Mud Run, it burned slowly for eight days until "a strong wind commenced to blow from the west. . . . In less than two hours the fire swept from Francis Youndt's mill directly up Mud Run, a distance of ten miles, destroying mills, houses, logs, timber and standing trees." (Mathews and Hungerford.) (Postcard courtesy of Glenn Finsel.)

MOSEY WOOD LAKE · IN THE POCONOS

MOSEY WOOD, LAKE HARMONY, C. 1900. As new life evolved and the green returned to the forest after the fire, hunting and fishing resorts were established, including Split Rock Lodge, named for the famous split rock. The streams filled with brook and native trout, and the forest with white-tailed deer and bear once again. Taverns, hotels, and ski areas abound. (Postcard courtesy of Glenn Finsel.)

TWINNING BROSNAN PIERS. Many people were smitten with the streams and lakes of upper Carbon County, a mere prelude to the magnificence of the forest. An Eden on a very primitive level, the Great Pine Swamp was a place of lush isolation compared to the coal and canal towns to the south, near Mauch Chunk. This terrain appealed to a different type of settler. Up until the very late 1800s, only the toughest and most resilient stayed on amidst the hovering danger of chronic sawmill fires and the isolation of harsh winters. A promised land of hemlock and white pine, the forest was populated with a profusion of sawmills, tenement houses, and the largest hide tannery in the country. Later, wintergreen distilleries and a brick factory were landmark. Now these forest lands are mainly for pleasure; water-skiing and boating abound on Lake Harmony in summer, and in winter it is known for its wonderful skiing. (Postcard courtesy of Glenn Finsel.)

SUNNYREST. The same pristine mountain air that appealed to the tourists of Carbon County was thought to have a healing effect on those afflicted with consumption, or tuberculosis. Just on the edge of the Great Pine Swamp is the smallest town in Carbon County, East Side Borough (formerly East Haven), along the Lehigh River. Sunnyrest, a private hospital complex and sanatorium for consumptives, was located there. "So overwhelming was the reception of the free sanatorium at White Haven that the need for a private sanatorium was met by Elwell Stockdale in November 1901. Mr. Stockdale left his job as superintendent at the White Haven Sanatorium to establish the private hospital named Sunnyrest. The success of the treatment at the free sanatorium was so gratifying that at once there was a demand for a private sanatorium." (Brenckman.) (Postcard courtesy of Juliana Rhodes.)

THE SUNNYREST GOLF COURSE. Sunnyrest had its own golf course and individual bungalows, although some experts felt that exercise was detrimental to the treatment of tuberculosis. This postcard of the golf course is from 1910, and this area of East Side Borough looks remarkably the same now as it does on this antique postcard. (Postcard courtesy of Juliana Rhodes.)

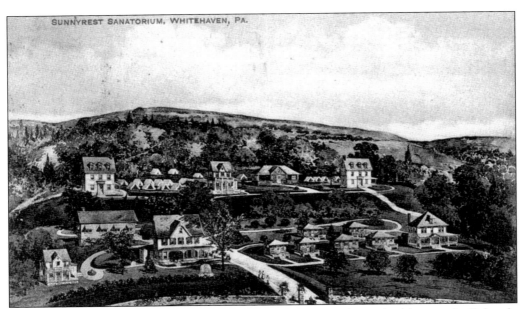

SUNNYREST FROM THE SOUTHWEST, 1910. Correspondence from a health resort in Colorado Springs addressed the stigma attached to people with tuberculosis: "It is a famous health resort, especially for consumptives, several of whom we met carrying the burden of their fell disease. There was at least, one patient at the Antler, whom I heard at nights but did not see, poor fellow. I would not care to recommend a hotel with such guests." (Postcard courtesy of Juliana Rhodes.)

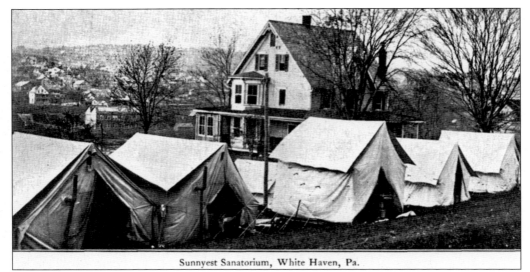

Sunnyest Sanatorium, White Haven, Pa.

SUNNYREST PATIENTS' TENTS. In the early 1900s, the threat of tuberculosis was a serious one. A diagnosis with tuberculosis could carry a death sentence. Conventional medicine did not have much to offer, thus the need for sanatoriums, where new methods of therapy could be tried. Many famous writers had consumption, including Robert Louis Stevenson, Henry David Thoreau, Anton Chekhov, John Keats, and the Brontë sisters. (Postcard courtesy of Juliana Rhodes.)

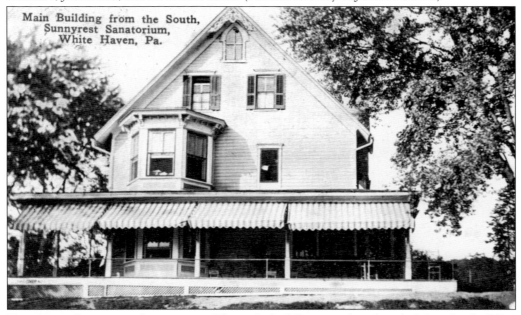

Main Building from the South, Sunnyrest Sanatorium, White Haven, Pa.

THE MAIN BUILDING, SUNNYREST. The main building served as the administration building for the sanatorium. In the following article, amateur nurses were advised how to treat consumption in their homes: "Pure air should be introduced into the sleeping room at night by having a fire if the air is cool and then leaving the window open protected with a flannel. Bad air is positive poison for consumptives. They should live out of doors as much as possible [and get] gentle exercise, nourishing food, tonics." (*Nursing the Sick,* Davis and Lawrence, 1897.) (Postcard courtesy of Juliana Rhodes.)

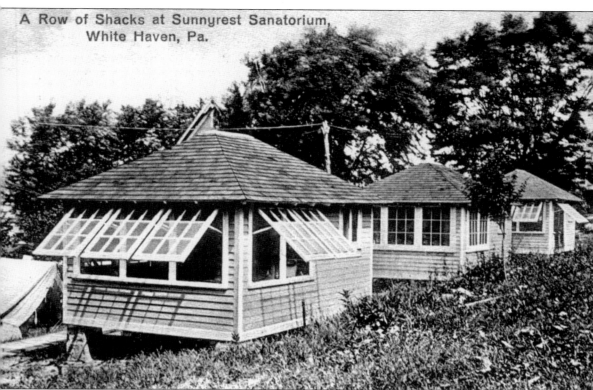

A Row of Shacks at Sunnyrest Sanatorium, White Haven, Pa.

ROWS OF SHACKS, SUNNYREST. In 1849, the poet Anne Brontë wrote her last letter before she died of tuberculosis. She states the following: "The doctors say that change of air or removal to a better climate would hardly ever fail of success in consumptive cases if the remedy were taken in time, but the reason why there are so many disappointments is, that it is generally deferred till it is too late. I am decidedly weaker and very much thinner and my cough still troubles me a good deal, especially in the night, and, what seems worse than all, I am subject to great shortness of breath on going up stairs or any slight exertion. Under these circumstances I think there is no time to be lost." (Postcard courtesy of Juliana Rhodes.)

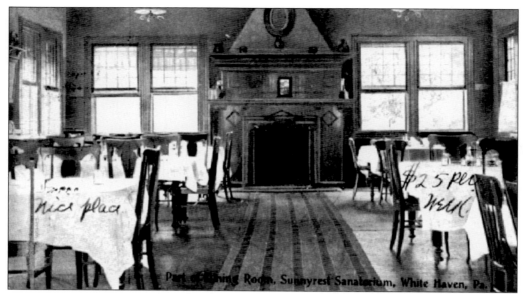

THE DINING ROOM, SUNNYREST. This postcard reads as follows: "From Sunnyrest Sanatorium 1917. Only have to take four quarts of milk and six eggs a day which I enjoy you know very much. Iva." Weight gain was an important sign that a patient was improving. A postcard from 1913 to Summit, New York, reads, "Alice enjoyed the card, so did I. She weighed today . . . 92-3/4 pounds. . . . Doctor says she may sit up some in bed. Weather is heavy today, hope it clears tomorrow. Ralph and Alice." (Postcard courtesy of Juliana Rhodes.)

A SUNNYREST BUNGALOW. Dr. Robert Koch was the first doctor to discover that the cause of the tuberculosis was a bacteria or microbe. This groundbreaking news led to the advanced treatments and cures that are available for tuberculosis today. This postcard was mailed in 1914 to Dr. Charles Hoopes, in Haddonfield, New Jersey: "Well I am here in bed since December 30th and some sick; I guess my throat is no better. I suffer terribly with it; I wish I could have one of your treatments so I can fall asleep tonight. E. Peterson." (Postcard courtesy of Juliana Rhodes.)

Five

THE MIDDLE COAL FIELD

*In the year 1791, there lived on the eastern slope of the mountains drained by the Lehigh
River, in Pennsylvania, a hunter, named Philip Ginther. . . . As the shades of evening
gathered around [after a day of hunting], he found himself on the summit of Sharp
Mountain several miles distant from his home. Running along at a brisk gait
through the woods, he stumbled over the roots of a tree which had recently fallen, and threw
before him a large, black stone—to recognize which, and the black aspect of the spot
around the roots, there was yet remaining sufficient light. He had heard persons speak of
stone coal as existing in these mountains, and concluded that this must be a specimen.*

—*Coal and the Coal-Mines of Pennsylvania,* 1857

Philip Ginder's discovery was one of great importance. Carbon County became part of what
would later be named the Middle Coal Field of Pennsylvania. The Middle Coal Field is made up
of many small mining towns and villages. Among them, Packerton, small and well kept between
Lehighton and Mauch Chunk, was an important stop along the Beaver Meadows Railroad.
Although not a coal-mining village per se, it was purchased by Asa Packer sometime after 1887 to
expand operations for the Lehigh Valley Railroad. The ghostly remains of the cavernous train yard
still remain along Route 209, the dark hulk of what was once the site of bustling activity.

The mining town of Beaver Meadows began with the discovery of coal in 1812, after which
the Beaver Meadows Railroad was built. In 1910, it was reported that "the town contains five
streets [and] two . . . main thoroughfares; Broad Street is the old turnpike from Mauch Chunk
to Berwick." Colerain and Audenreid were coal-mining towns. Operations began there soon
after the opening of the Beaver Meadows Railroad, and "a large and modern breaker handling
the output of several nearby collieries was erected in this area in 1909." Other coal towns of
Carbon County include Lansford, Nesquehoning, Coaldale, and Trescow, with mine disasters
such as fires and cave-ins part of the scene. Mining was an excruciating profession, one with many
dangers for very little pay. The following is a passage from *Coal and the Coal-Mines of Pennsylvania:*

It is a lamentable fact—and to such as have occasion to descend into the mines whose
ventilation is imperfect, it is by no means a pleasant reflection—that out of a gang of fifty or
sixty men you can always count on a certain proportion of ignorant and reckless characters,
who hold the lives and limbs of all the others in the tenure of their criminal folly and stupidity.

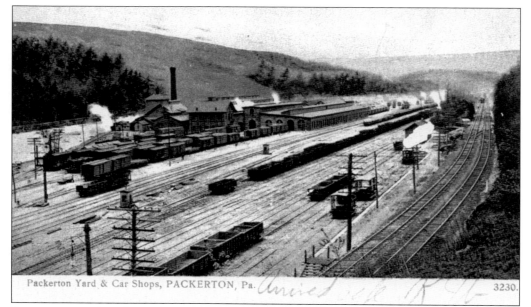

Packerton Yard & Car Shops, PACKERTON, Pa. *Arrived* _____ _____ *R*_____ 3230.

PACKERTON. The village of Packerton, a stop on the Beaver Meadows Railroad, was purchased by Asa Packer to expand railroad operations. Packer envisioned it as the shipping headquarters for "all coal passing east." Only the ghostlike structures of a once magnificent Lehigh Valley Railroad "car shop and roundhouses" remain now, keeping vigil across the road from this quaint village. These shops once housed 12,000 locomotive cars. (Postcard courtesy of Glenn Finsel.)

Packerton Yards L. V. R. R, Lehighton, Pa.

THE PACKERTON YARD AND TRACKS. Packerton had a population of approximately 300 at the turn of the century. The huge brick building at the Packerton yard was the shipping department, which housed "the weight scales, over which passed the entire tonnage east, reaching several million tons per annum." Hundreds of men worked in these shops. Eventually Harry E. Packer replaced his father as president of the Lehigh Valley Railroad. (Postcard courtesy of Clarence Getz.)

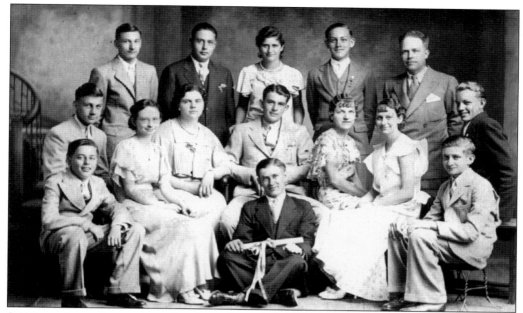

SCHOOL. A conglomeration of tracks at the Lehigh Valley Railroad yard can be seen from the school grounds of the former Packerton High School. The only school in Carbon County to have "fire chutes" for the students to escape through in case of fire, it is located high on a hill above Packerton, just as the home of its benefactor, Asa Packer, overlooks Jim Thorpe. (Postcard courtesy of Glenn Finsel.)

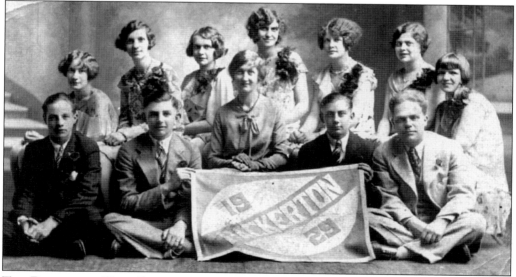

THE PACKERTON HIGH SCHOOL CLASS OF 1929. Packerton was a separate school and election district, independent of Lehighton and Mauch Chunk. The handsome, well-constructed brick schoolhouse was a gift from Asa Packer. In the late 1800s, the village of Packerton had a Methodist church, two shops, and a fine hotel established by Leopold Myers. (Postcard courtesy of Glenn Finsel.)

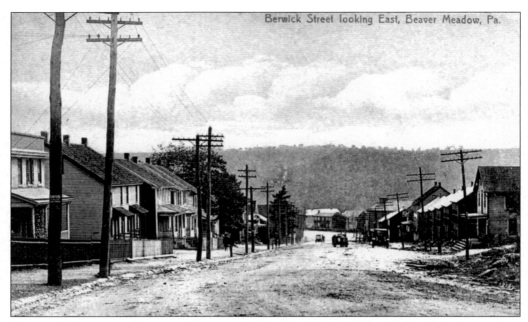

Berwick Street looking East, Beaver Meadow, Pa.

BEAVER MEADOWS, BERWICK STREET, 1900. The Lehigh Valley Railroad had operations from Packerton to Beaver Meadows. In 1864, the Lehigh Valley purchased the Beaver Meadows Railroad. Home of the Beaver Meadows Mine, this was one of the quintessential coal-mining towns of Pennsylvania. (Postcard courtesy of Richard Funk.)

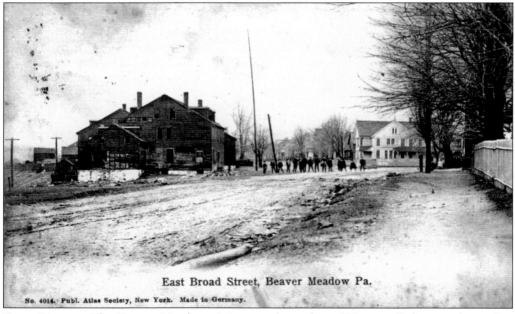

East Broad Street, Beaver Meadow Pa.

No. 4014. Publ. Atlas Society, New York. Made in Germany.

EAST BROAD. The Beaver Meadows Mine was located on 200 acres "where coal was first discovered." As for its name, "Beaver Meadows has never been to my knowledge 'alive with beavers.' I have been acquainted with this region since 1831 and I have never seen a beaver or a sign of one. Many years ago signs of beaver dams were discovered along the creek [thus] the name Beaver Swamp." (Longshore.) (Postcard courtesy of Richard Funk.)

114

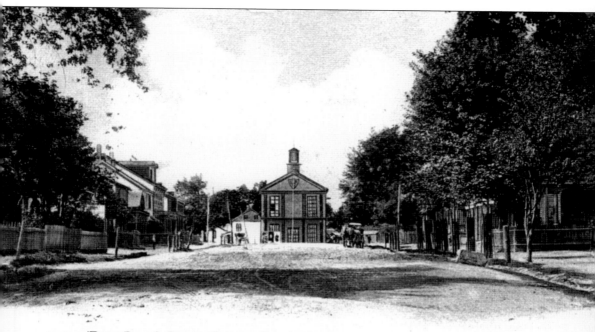

10921 West Broad Street, Beaver Meadows, Pa..

Yours for exchange, Respectfully, W Ed Dickerson

WEST BROAD, BEAVER MEADOWS. "I will give a resume of my experiences as a railroader. . . . The locomotives took in water at the station where we were waiting. The rear engine took our truck to Weatherly or Black Creek as it was then called. There was not a house there at the time and not any of the land was cleared, except what was necessary for the road and sidings. When we arrived there Eastwick discovered that the water was low in the boiler, so he started down the grade to pump. There was no brake on the tender; the engine started to travel pretty fast; an attempt was made to reverse the steam and it was discovered there was none to reverse. About half way to Penn Haven there was a level spot for a short distance. The fireman took the poker, leaned over the railing and thrust it through the spokes of the driving wheel. The locomotive stopped just on the brink of another grade. It took five mules to haul it up the grade to the planes." (Longshore.) (Postcard courtesy of Richard Funk.)

115

CHURCH STREET: AUDENRIED. PA.

his is the street we live on. I hope you get this
... I send you one before and you didn't get ...
... From ...

AUDENREID. Describing life as a young railroader, Alfred Longshore wrote, "Our day started at 4 o'clock in the morning and two hours later when the steam was up we were ready for the start to Parryville. We could make the trip down very easily, but on the return trip sixteen cars were too much for the engine and we had to stop several times to get up steam. We used hemlock wood and frequently had to use water from the Lehigh when the boilers were nearly empty. When we stopped, the draft was shut off and the fire died out. Then we had to climb around on the mountains to gather pine knots for kindling.

"It used to take two days and a night to go to Philadelphia. I remember the first man who came through from Philadelphia to Beaver Meadow in one day. He left the city at 5 o'clock in the morning; got off the train at Port Clinton; took the stage to Tamaqua, where he hired a horse and drove to Beaver Meadows arriving a little after dark. We were all anxious to see the man who performed so great a feat." (Postcard courtesy of Richard Funk.)

Coleraine, Pa.

COLERAINE. The following description by Longshore paints a vivid picture: "In the 1830s, wolves and deer were especially plentiful. It was not unusual to see herds of deer feeding on the hills, also most within gunshot. At the time we could hear the wolves howling around the houses at night. There were also bears, wild cats and panthers."

Public School Building, Audenried, Pa.

AUDENREID SCHOOL. Between 1836 and 1866, railroads were not yet popular. The old stagecoaches were still used. "The Mauch Chunk and Berwick stage reached here [Beaver Meadows] about eight or nine o'clock and Berwick about noon. It waited in Berwick until two o'clock the following morning and then continued on to Wilkes Barre which was reached at about seven in the morning." (Longshore.) (Postcard Courtesy of Richard Funk.)

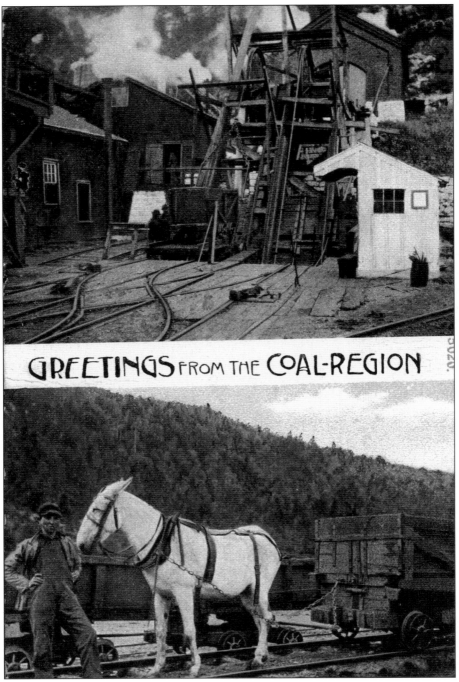

GREETINGS FROM THE COAL-REGION

BEAVER MEADOWS. Mining towns, such as Coleraine and Audenreid, prospered with the coal mines and the railroads. Hopkin Thomas invented the 10-wheel locomotive, the first of its kind in this country. Called the *Nonpareil,* it was constructed at the Beaver Meadows shops, which later moved to Weatherly. In 1865, "gradual reductions had brought wages of miners down by almost one dollar per car load. On this decline, there was a strike." (Postcard courtesy of Fred Bartelt.)

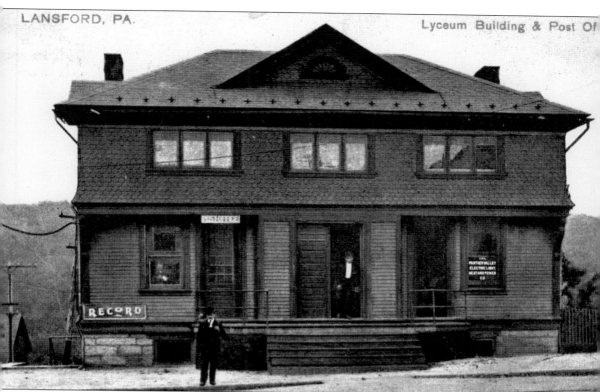

LANSFORD. Although miles away from Beaver Meadows and Audenreid, the mining town of Lansford was similar in culture. There was not "much sympathy between the miners and the corporations. . . . The men felt bitter toward their employers from their showing so little respect for their manhood as not to be willing to consult with them," especially when strikes loomed on the horizon in the late 1800s. (Gibbons.) (Postcard courtesy of Fred Bartelt.)

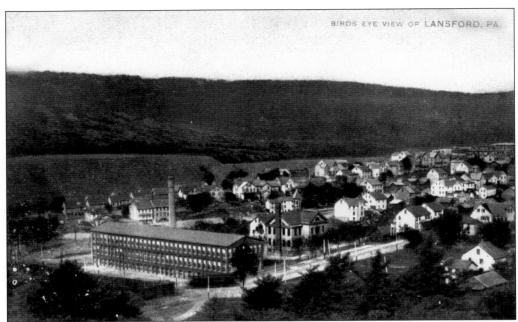

A Lansford View. "The Honorable Asa Lansford Foster was the personage of whom the town of Lansford was named. Lansford was comprised of two former mining settlement/towns named Ashton and Storm Hill. Simplistic as it sounds, Storm Hill was named from an incident when the home of Peter Fisher was blown over in its entirely during a severe storm. Storm Hill was located on the part of Lansford that is now the East. The Lehigh Coal and Navigation Company was affiliated with Lansford and had offices there." (Wagner.) (Postcard courtesy of Fred Bartelt.)

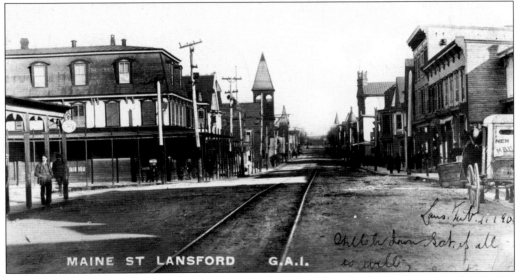

Main Street, Lansford. In 1910, the assessed value of Lansford's property was $4,655,454, and the population was just over 8,300, according to that year's census. Intent on providing the best education for the children of this small town, the borough employed 28 teachers in 1910–1911 and 1 superintendent of schools. This postcard shows the downtown area of Lansford in the early 1900s. (Postcard courtesy of Robert Gelatko.)

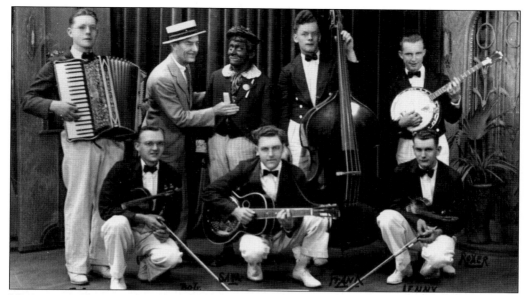

MINSTRELS. Here we step away from the northern coal-mining towns to the southern part of Carbon County. These musicians were from Bowmanstown, and the band was called the Variety Boys. The photograph includes two brothers, Lenny (front row, far right) and Frank Meckes (back row, second from the right). This picture may have been taken by their sister, Irene Meckes, *c.* 1915. The date of the settlement of Bowmanstown (formerly Bowmans) was before 1791. Named after Henry Bowmans, the town is located in the shadow of the Blue or Kittatinny Mountains, by which it is loosely bordered at the south. (Postcard courtesy of Linda Hunsicker.)

THE BAMBOO BAR. Shown is a very collectible postcard from the 1920s. Referring to the history of Lansford, Wagner writes, "The name Ashton was applied to a cluster of houses which stood where the western part of Lansford has since been built. Lansford is located on the plateau, which forms the first terrace above Panther Creek Valley as one ascends the mountain toward Summit Hill. The borough now includes an area approximately one and one fourth miles long by one half of a mile wide." (Postcard courtesy of Fred Bartelt.)

THE PALMERTON ZINC COMPANY. This very rare postcard was provided courtesy of Nancy Shaffer, whose father used this very same exit every day that he worked for the Palmerton Zinc Company. According to Wagner's history of 1910, "Palmerton has, during the past few years, evolved from a scraggly, long drawn out minor manufacturing village into a model town so far as homes, schools, sanitations and general municipal improvements are concerned and more is promised." Located within a "very short distance of the anthracite coal region," Palmerton was named for Stephen S. Palmer, president of the New Jersey Zinc Company, the primary industry of this town for over 80 years.

PARRYVILLE. "A settlement was started at this place in 1770 by Peter Frantz, it is situated at the junction of the Poho Poco Creek and the Lehigh River. Connected to the Beaver Meadow Railroad Company in 1836, it was a shipping point for coal." The anthracite blast furnace was established in 1855 and was still the principal business in 1910, according to Wagner's history of the same year. The road through Parryville, called Fire Line, has great historical significance, as this was where the Moravians of Gnadenhutten built fires to inform the "brethren in Bethlehem of the condition of affairs." (Postcard courtesy of Hilbert Haas.)

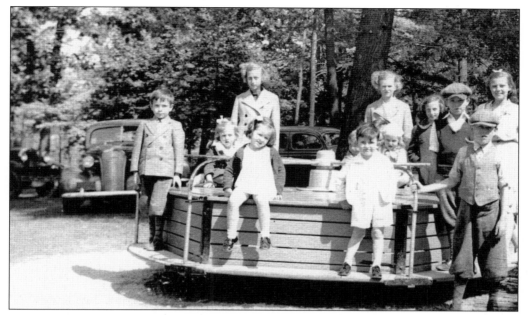

THE FOREST INN MERRY-GO-ROUND. "You may give them your love but not your thoughts. . . . You may house their bodies but not their souls, for their souls dwell in the house of tomorrow, which you may not visit, not even in your dreams." (Kahlil Gibran.) These Carbon County children pause for just a moment near Forest Inn, on Route 209, their world of play recorded for posterity by the photographer's intrusion. (Postcard courtesy of Clarence Getz.)

Main Street, Lansford,

LANSFORD AND THE MANSION HOUSE, C. 1907. A treasured view of Lansford's old downtown section is preserved by the postcard photographer. The Mansion House was an extremely popular name for Carbon County hotels in this era; there were Mansion House hotels in Summit Hill, Lehighton, and Mauch Chunk. (Postcard courtesy of Clarence Getz.)

Birds Eye View of Nesquehoning, Pa. *From Cora M. Richar*

NESQUEHONING. In 1785, coal was discovered in Nesquehoning, a small mining town whose American Indian name, loosely translated, means "narrow ravine or valley." Coal from the Nesquehoning mines was transported to Mauch Chunk on the Room Run Railroad. Then mules were used to haul the empty cars back to the mines. The Nesquehoning Valley Railroad replaced the Room Run Railroad in 1830. (Postcard courtesy of Fred Bartelt.)

Catawissa Street, Nesquehoning, Pa. *Baby is like himself again. Log a letter. All well hope you all are ...*

LABOR STRIKE. The United Mine Workers Union began a strike in 1902, which culminated into one of the longest and most complex labor disputes in the history of the mines. Tempers flared and miners felt betrayed when the mines hired scabs, who crossed the picket line to work. Months without income caused hardship for the miners, who were low on food, supplies, and morale, but they remained loyal to their union. Sympathetic toward their neighbors, Carbon County residents donated food for the miners and their families. (Postcard courtesy of Fred Bartelt.)

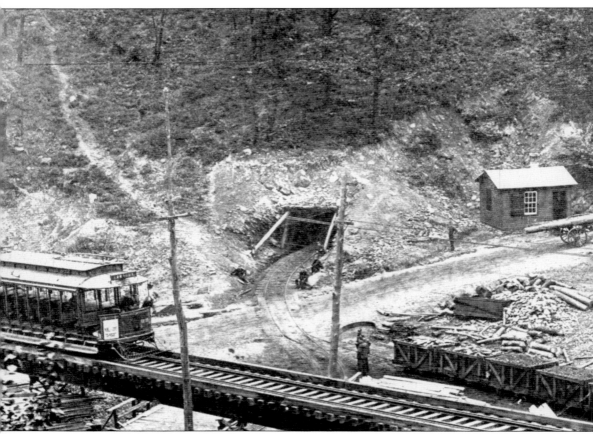

NESQUEHONING TUNNEL NO. 1. Patrick Sharpe, a coal miner, was murdered in Nesquehoning during the coal strike of 1902. Shot dead by deputies, his death became symbolic of the miners' struggles, and he was labeled a martyr for the cause. In August 1903, crowds of people from the Pennsylvania coal fields traveled to Summit Hill to see the unveiling of a monument to Sharpe at St. Joseph's Cemetery. This historic cemetery is the resting place of the Molly Maguires' Alex Campbell, who proclaimed his innocence by placing his handprint on the wall of the historic Jim Thorpe Jailhouse.

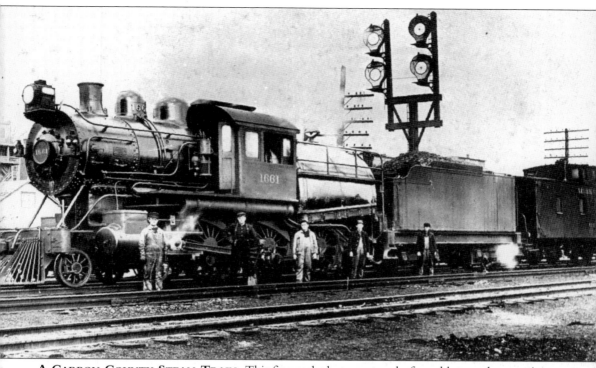

A CARBON COUNTY STEAM TRAIN. This fine real-photo postcard of an old steam locomotive and its railroaders captures the ambiance of the days of train travel in Carbon County. Whether this is the legendary Black Diamond of the Lehigh Valley Railroad remains unknown. It could also possibly be one of the trains of the New Jersey Central Railroad, but we do know that the photograph was taken in Carbon County *c.* 1901. Note the carload of coal in the center. The Black Diamond Express was the only train that became a celebrity, as a short film of the train was advertised for sale in Thomas Edison's Film Catalog. (Postcard courtesy of Clarence Getz.)

BIBLIOGRAPHY

Audubon, John James. *The Birds of America*. London, 1860.

Bethlehem Digital History Project, Moravian Archives, Reeves Library, online database. *Journals—Gnadenhutten, 1752*. Bethlehem: Moravian College.

Brenckman, Fred. *History of Carbon County, Pennsylvania*. Harrisburg: James J. Nungesser, 1913.

Brinton, Daniel G. *The Lenape and their Legends with the Complete Text and Symbols of the Walum Olum, A New Translation and an Inquiry tin its Authenticity*. Philadelphia: D. G. Brinton, 1885.

"Coal, and the Coal-Mines of Pennsylvania." *Harper's New Monthly*. June 1857.

Fowler, William Worthington. *Woman on the American Frontier, a Valuable and Authentic History of the Heroism, Adventures, Privations, Captivities, Trials and Noble Lives and Deaths of the Pioneer Mothers of the Republic*. Hartford: S. S. Scranton, 1881.

Gibbons, Phebe Earle. *Pennsylvania Dutch and Other Essays*. Philadelphia: J. B. Lippincott & Company, 1882.

"Gnadenhutten." *Atlantic Monthly* Vol. XXIII. 1869.

Johnson, Frederick C. "Count Zinzendorf and the Moravian and Indian Occupance of the Wyoming Valley, 1742–1763." Read to the Wyoming Historical and Geological Society, 19 May 1894.

Kelton, Cap. Dwight H. *Indian Names of Places Near the Great Lakes, Vol. 1*. Detroit: 1888.

Lanier, Sidney, Edward Pollars, and Edward Strachan. *Some Highways and Byways of American Travel*. Philadelphia: J. B. Lippincott, 1878.

Lehigh Coal and Navigation Company. *Rules and Regulations, under which all hands are employed*. Mauch Chunk: A. Sisty, Printer.

Lehigh County Historical Society. *Vol. 21, The Letter Book of Jacob Weiss, Deputy Quartermaster General of the Revolution*. Allentown: Melville J. Boyer Company, 1956.

Longshore, Alfred R. *Reminiscences of an Early Railroader*. Annals of the Sugar Loaf Historical Association, Vol. II. Hazleton, 1935.

Loskiel, George Henry. *History of the Moravian Mission Among the Indians of North America from its Commencement to Present Time*. London: T. Allman, 1838.

Lyell, Sir Charles. *Travels in North America, Canada & Nova Scotia with Geological Observations*. London: J. Murray, 1855.

Mathews, Alfred and Austin N. Hungerford. *History of the Counties of Lehigh and Carbon in the Commonwealth of Pennsylvania*. Philadelphia: Everts & Richards, 1884.

Montgomery, Thomas Lynch. *Report of the Commission to Locate the Site of the Frontier Forts of Pennsylvania, Vol. I*. Harrisburg: 1916.

Morgan, Lewis H. *Houses and House-Life of the American Aborigines*. Washington, D.C,: Government Printing Office, 1881.

Morton, Eleanor. *Josiah White—Prince of Pioneers*. New York: Stephen Daye Press, 1946.

Murray, Amelia. *Letters from the United States, Cuba and Canada*. New York: G. P. Putnam, 1856.

Religious Tract Society (Great Britain). *Missionary Records: North America*. London: Religious Tract Society.

Schrabisch, Max. *Archaeology of the Delaware River Valley, Vol. 1*. Harrisburg: Publisher of the Pennsylvania Historical Commission, 1930.

Snyder, Rev. J. Franklin and Rev. Roy J. Freeman. *History of Weissport Pennsylvania with Illustrations in Connection with the Centennial Celebration in Honor of the Founder Jacob Weiss*. Lehighton: Hummel Printing House, 1928.

"The Adventures of Audubon from the Edinburgh Review." *The Living Age*. 27 August 1870.

"The Anthracite Problem." *Scribner's Monthly*. April 1871.

"The Gravity Road at Mauch Chunk." *Manufacturer & Builder* 5, no. 6 (1873).

Trumbull, J. Hammond. *Notes on Forty Algonkin Versions of the Lord's Prayer*. Hartford: American Philological Association, 1873.

Watson, John F. *Annals of Philadelphia and Pennsylvania*. Philadelphia: 1857.

Wagner, A. E. *History, Government and Geography of Carbon County, Pa*. Allentown: Press of Berkemeyer, Keck & Company, 1910.

White, Josiah. *Untitled Circular 2, no. 7*. Harrisburg: Hamilton and Son Printers, 1832.

Winterbotham, William. *An Historical, Geographical, Commercial, and Philosophical View of the American U.S. and the European Settlements in America and the West Indies*. London: J. Ridgway, 1795.

Wooley, Carolyn Murray. "The Stone Age Still With Us." *Stonexus*. Summer 2001.